Artbook TeemovsAll

Redes sociales/Social networks

 www.patreon.com/teemovsall

 www.youtube.com/teemovsall

 www.facebook.com/TeemovsAll-889554211121405

 twitter.com/TeemovsAll

Publicado en 2020 / Published in 2020

Copyright © Teemovsall

Todos los derechos de este libro están reservados y su copia sin previa autorización es ilegal. reproducida, almacenada en un sistema de recuperación o transmitida en cualquier forma o por cualquier medio, sea electrónico, mecánico, fotocopia, grabación o cualquier otro sin la atribución completa.
—
All rights reserved. No part of this publication may be reproduced, stored in a retrieval system, or transmitted in any form or by any means, electronic, mechanical, photocopying, recording or otherwise without full attribution.

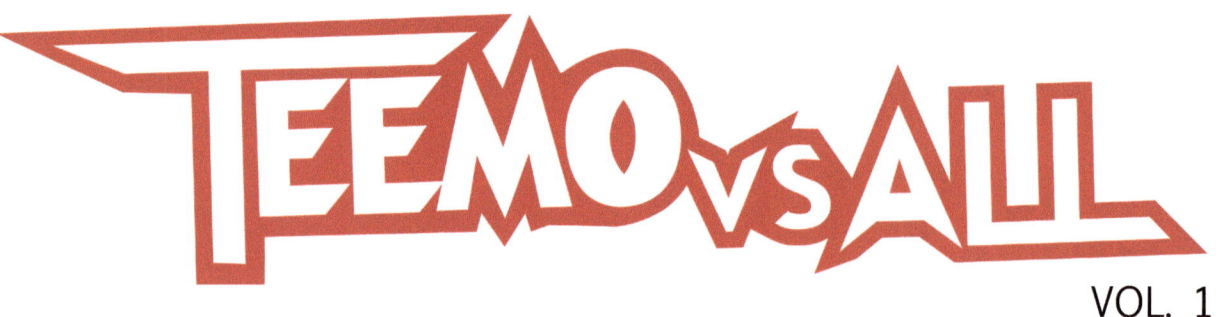

TEEMO vs ALL
VOL. 1

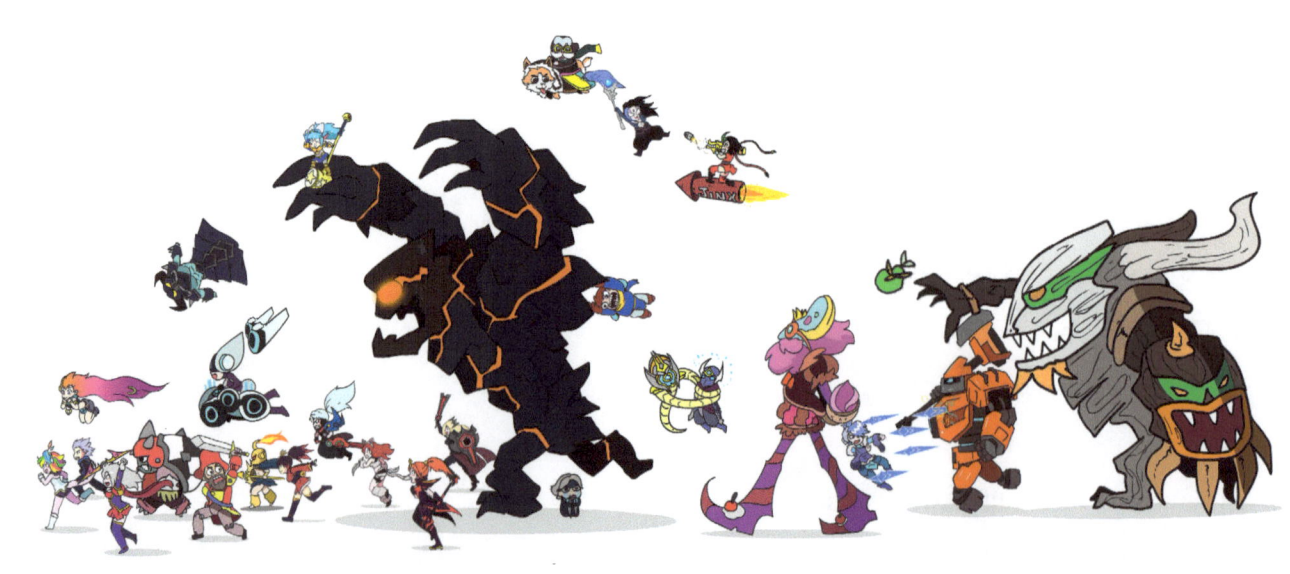

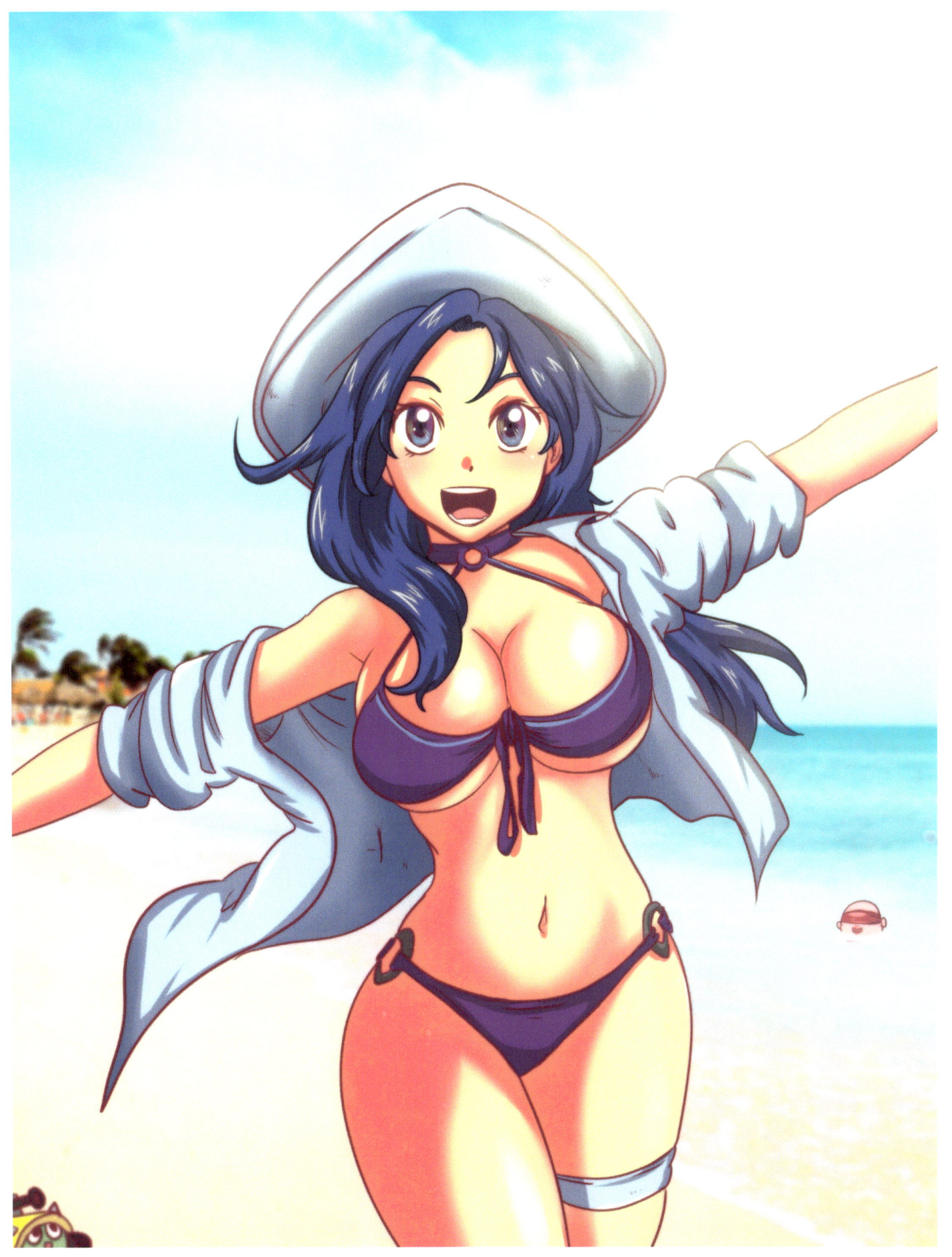

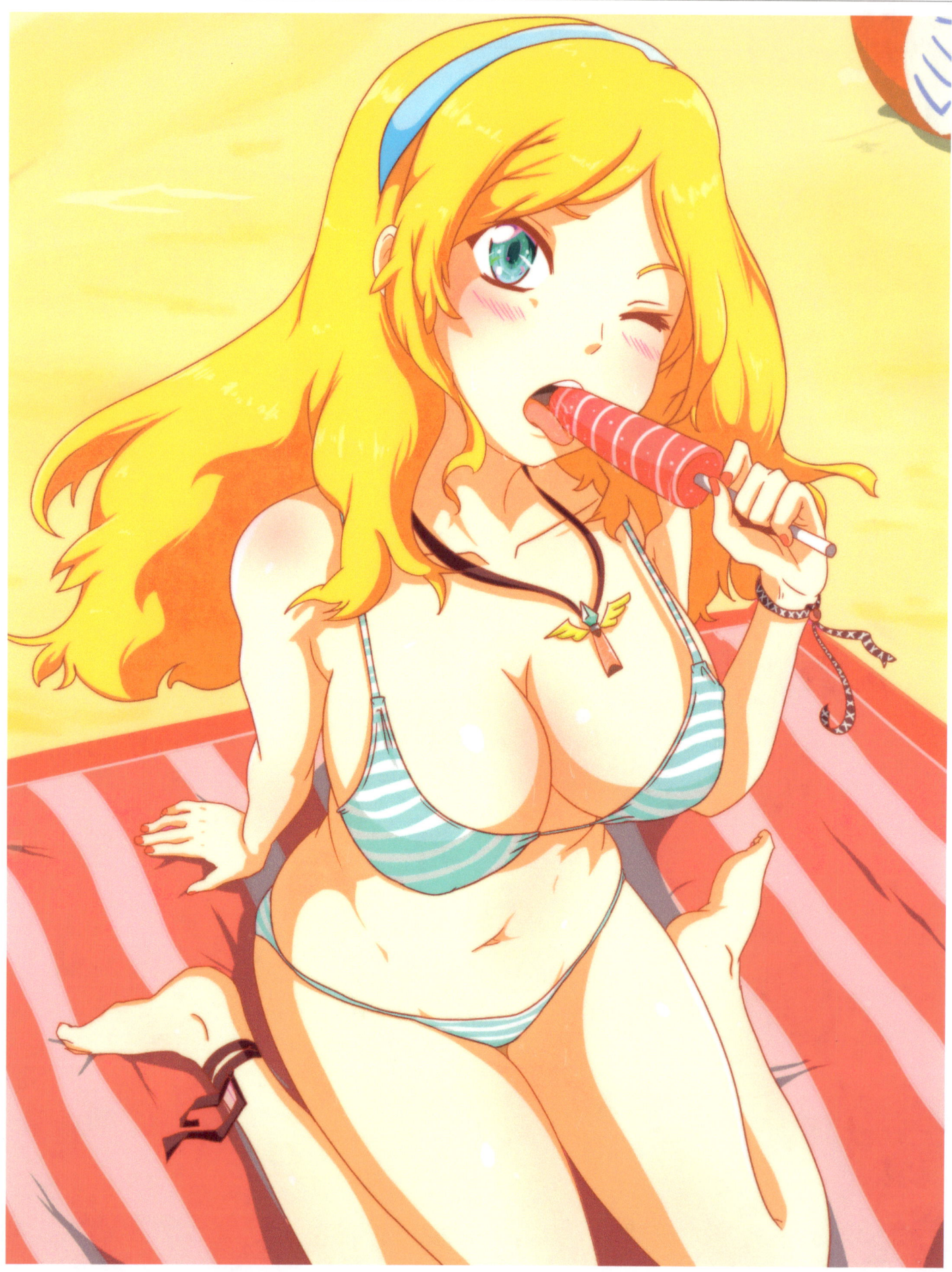

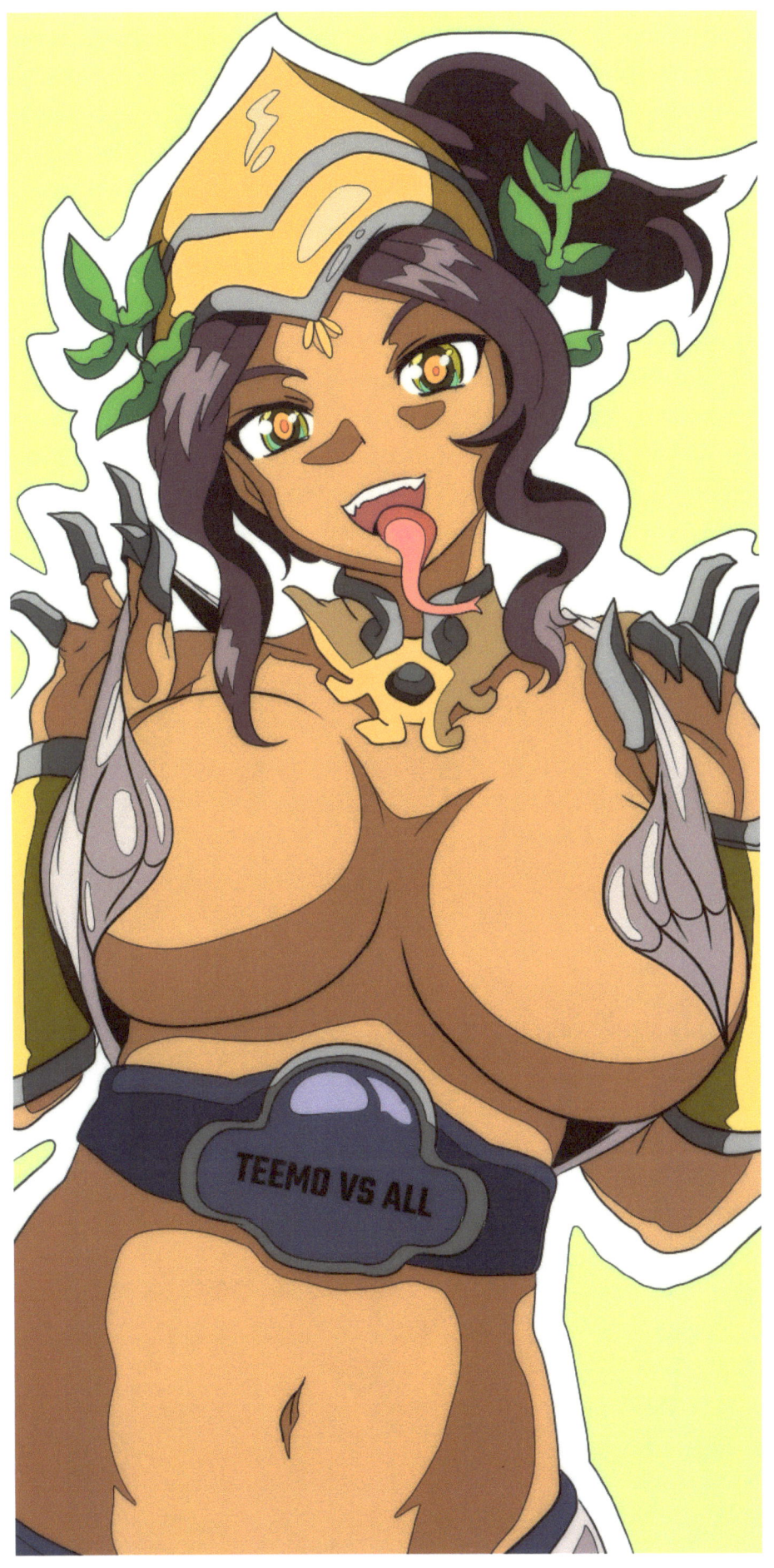

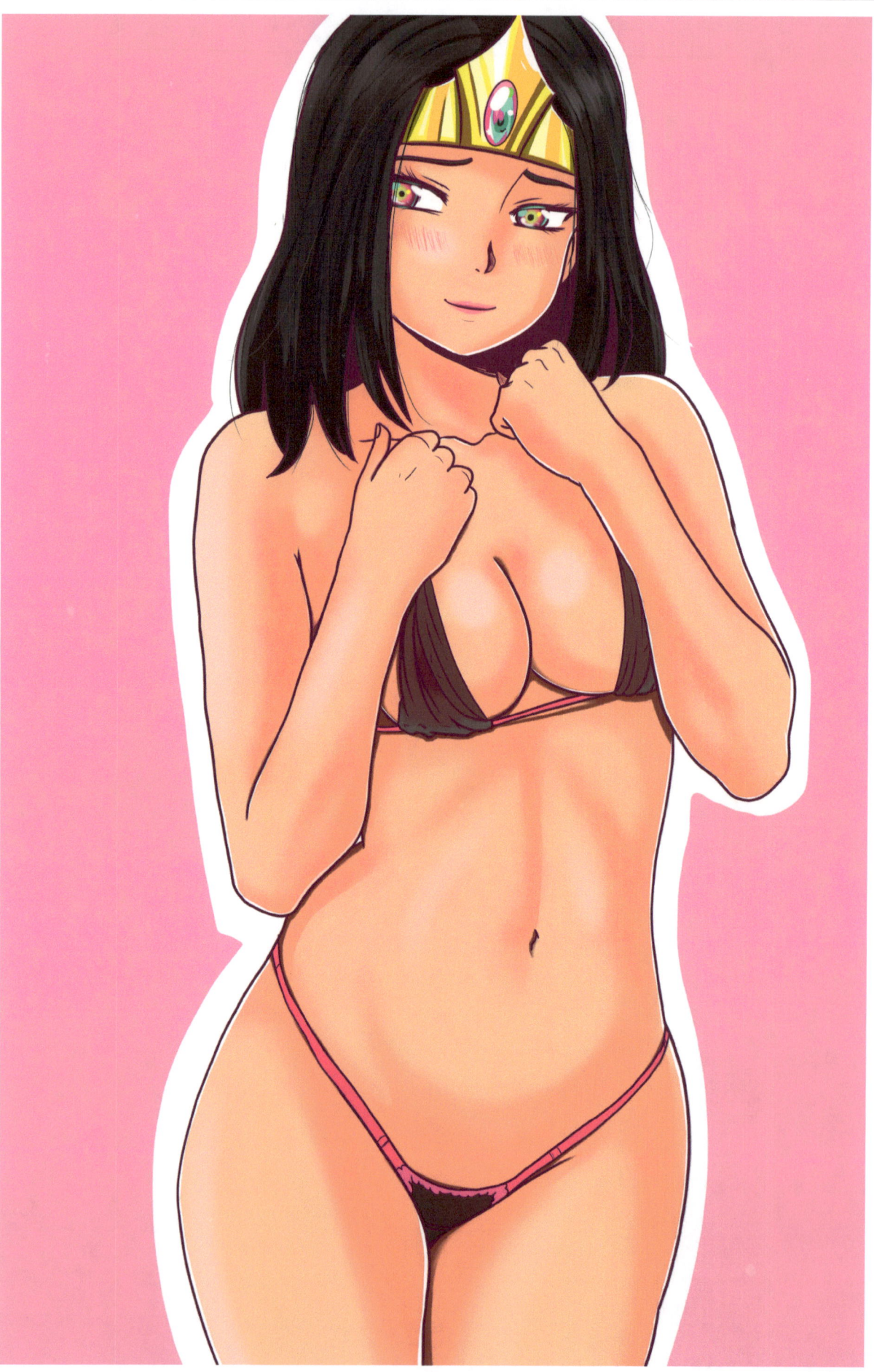

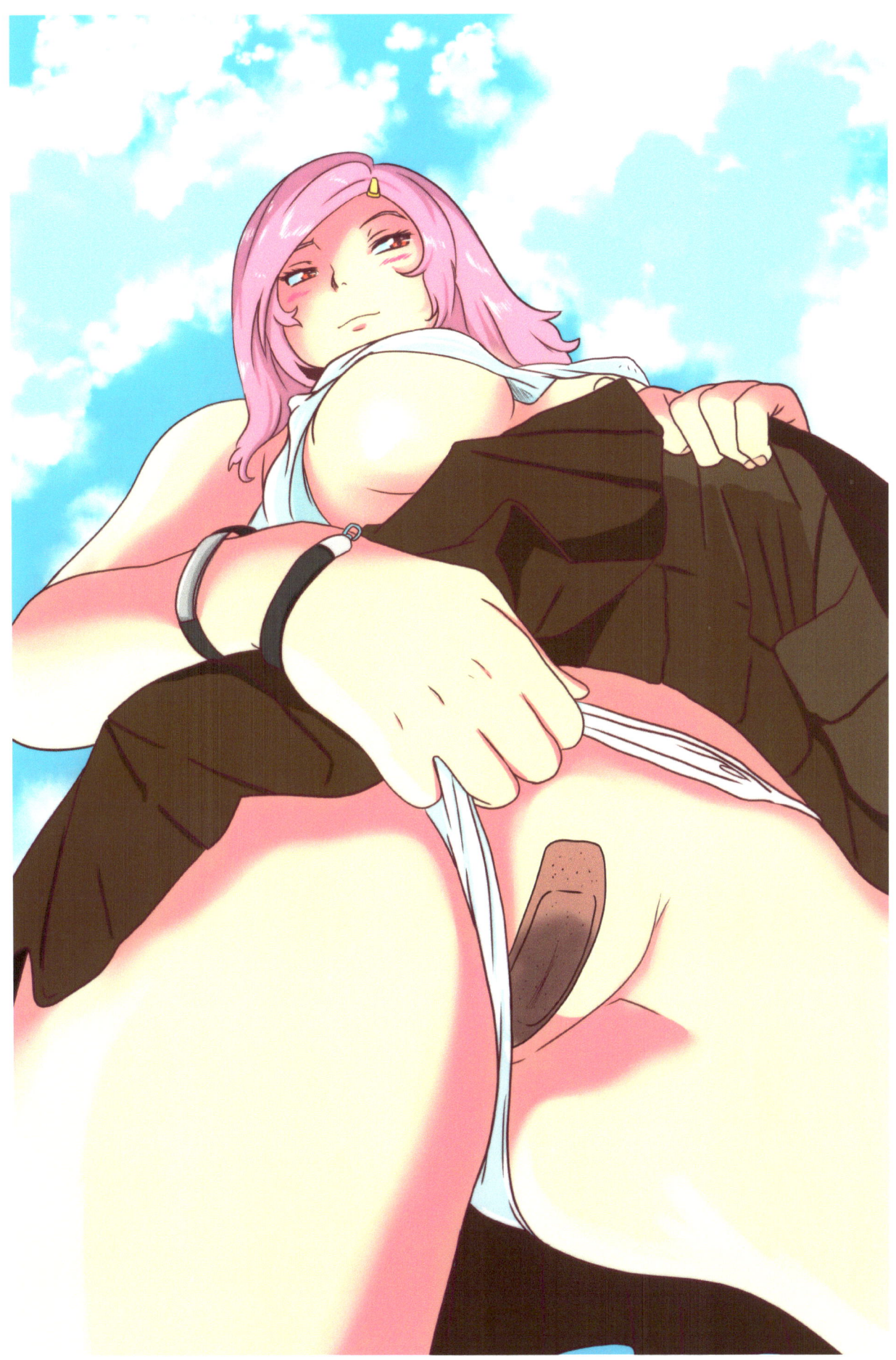

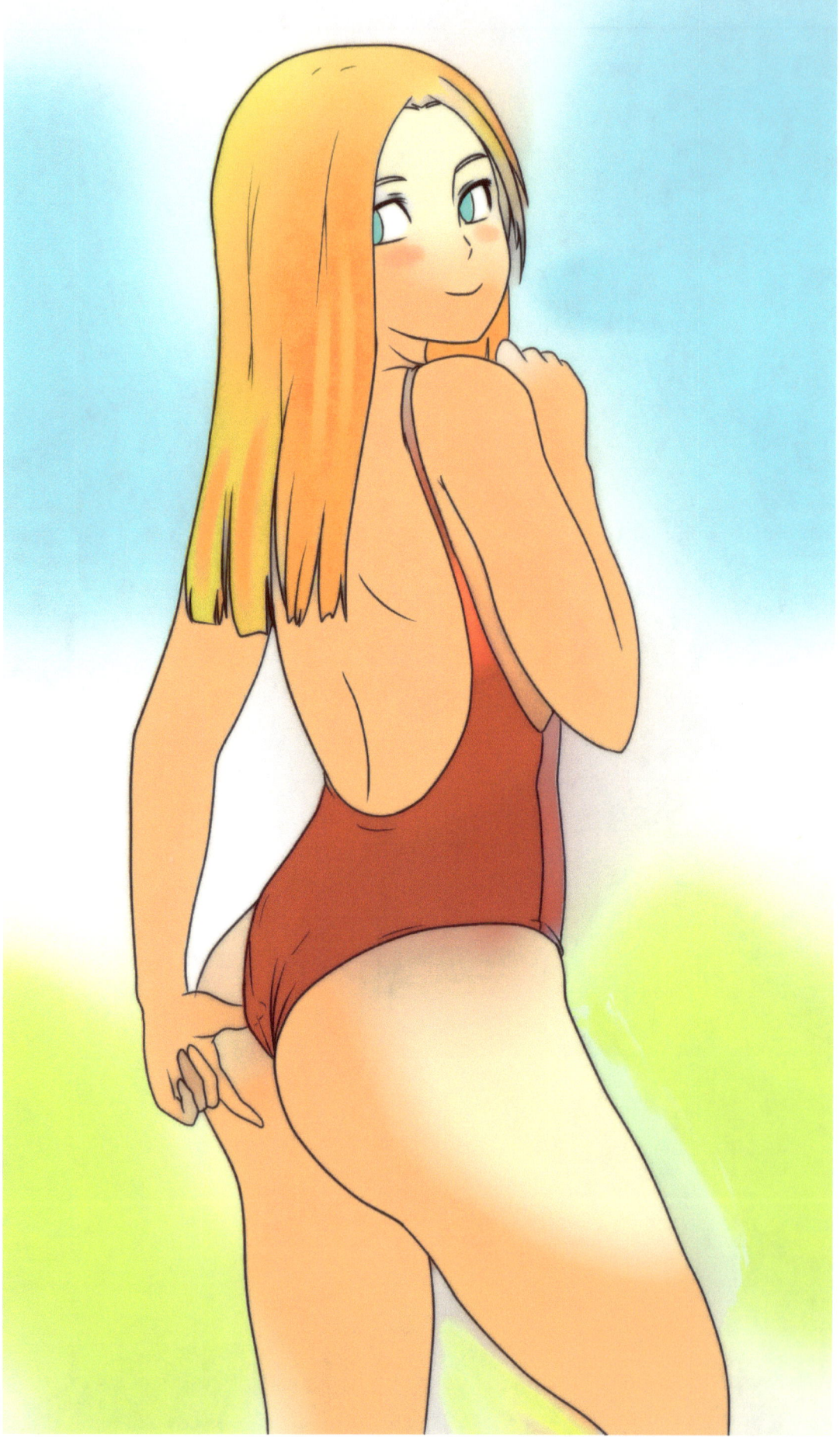

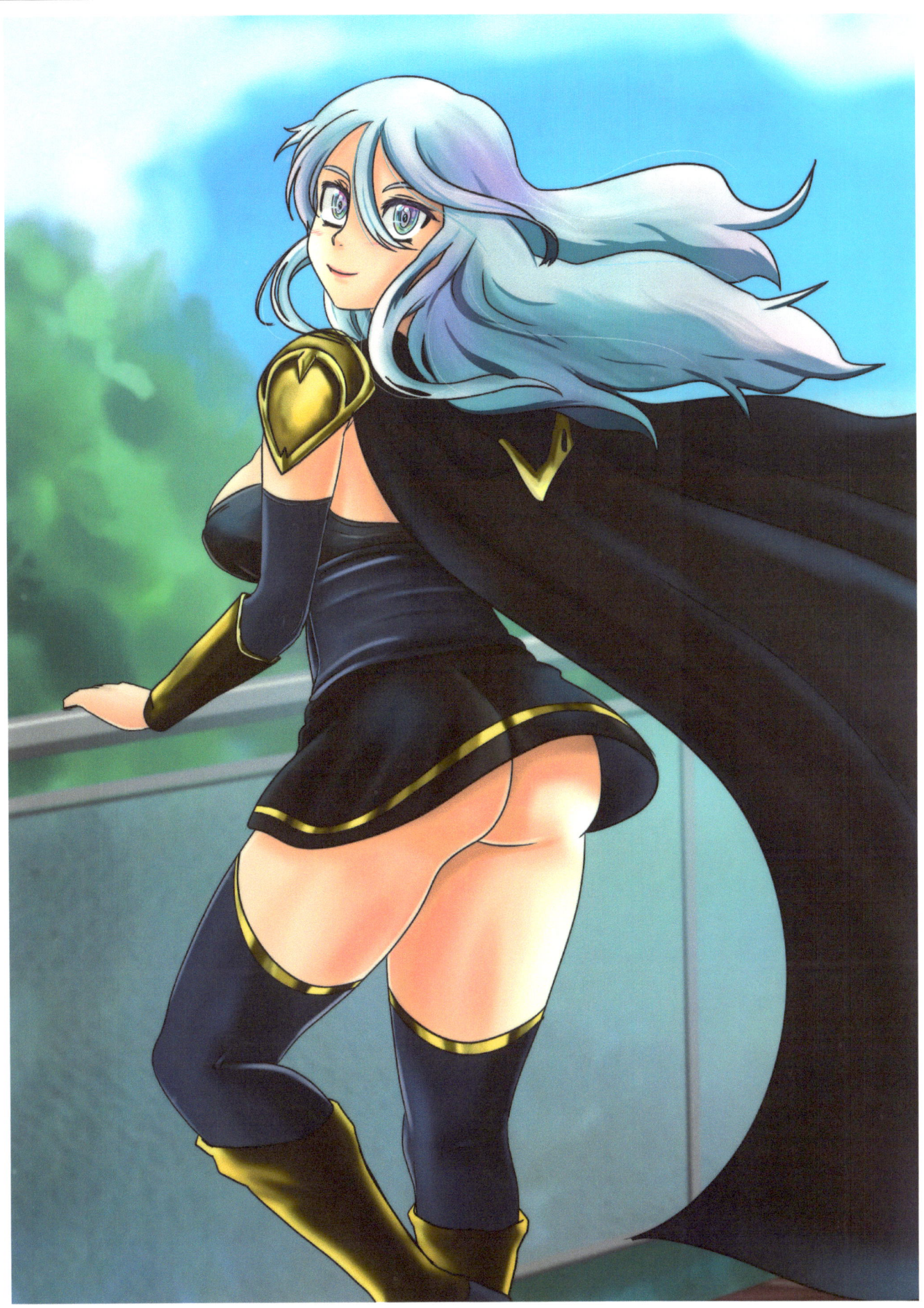

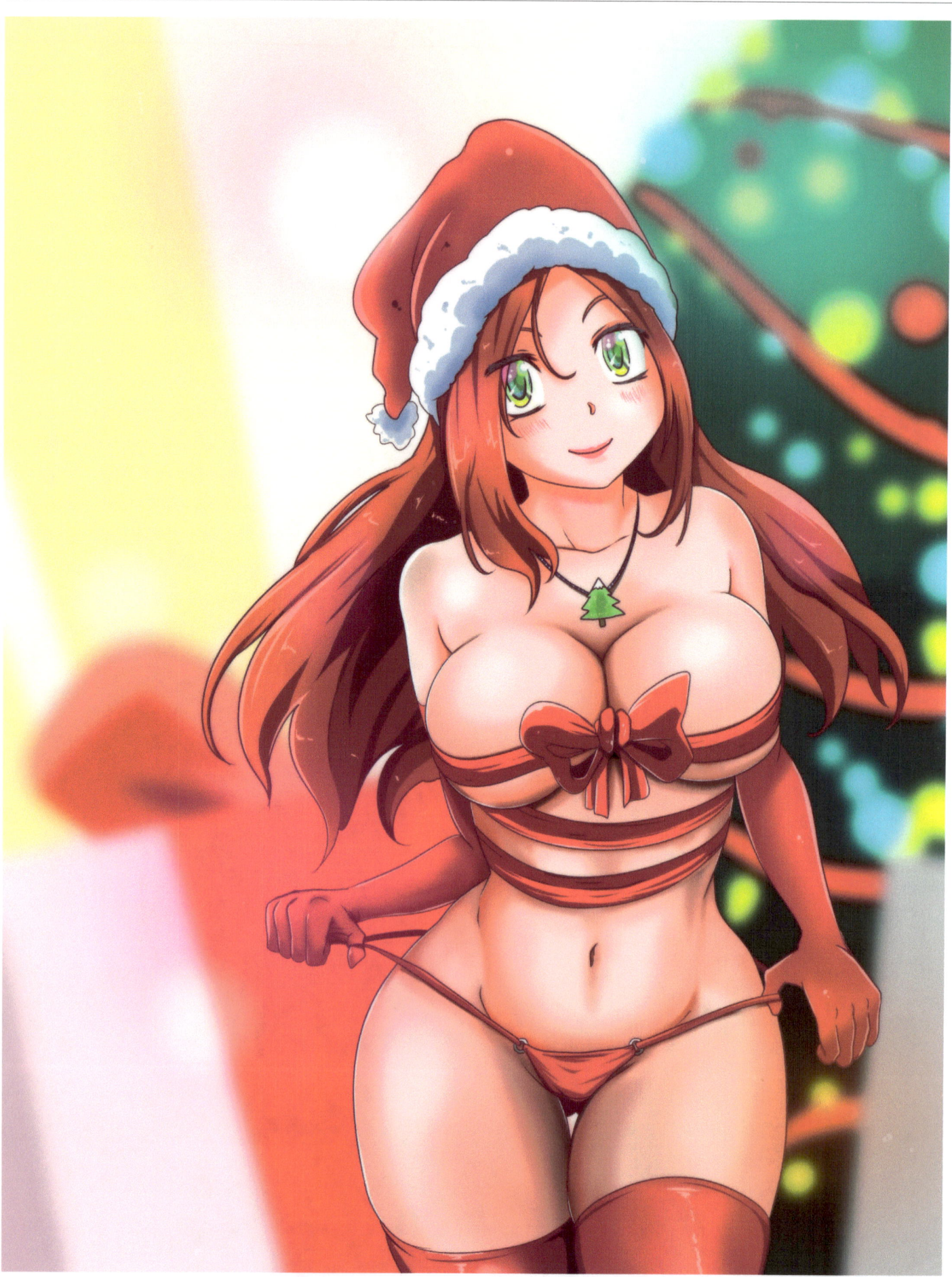

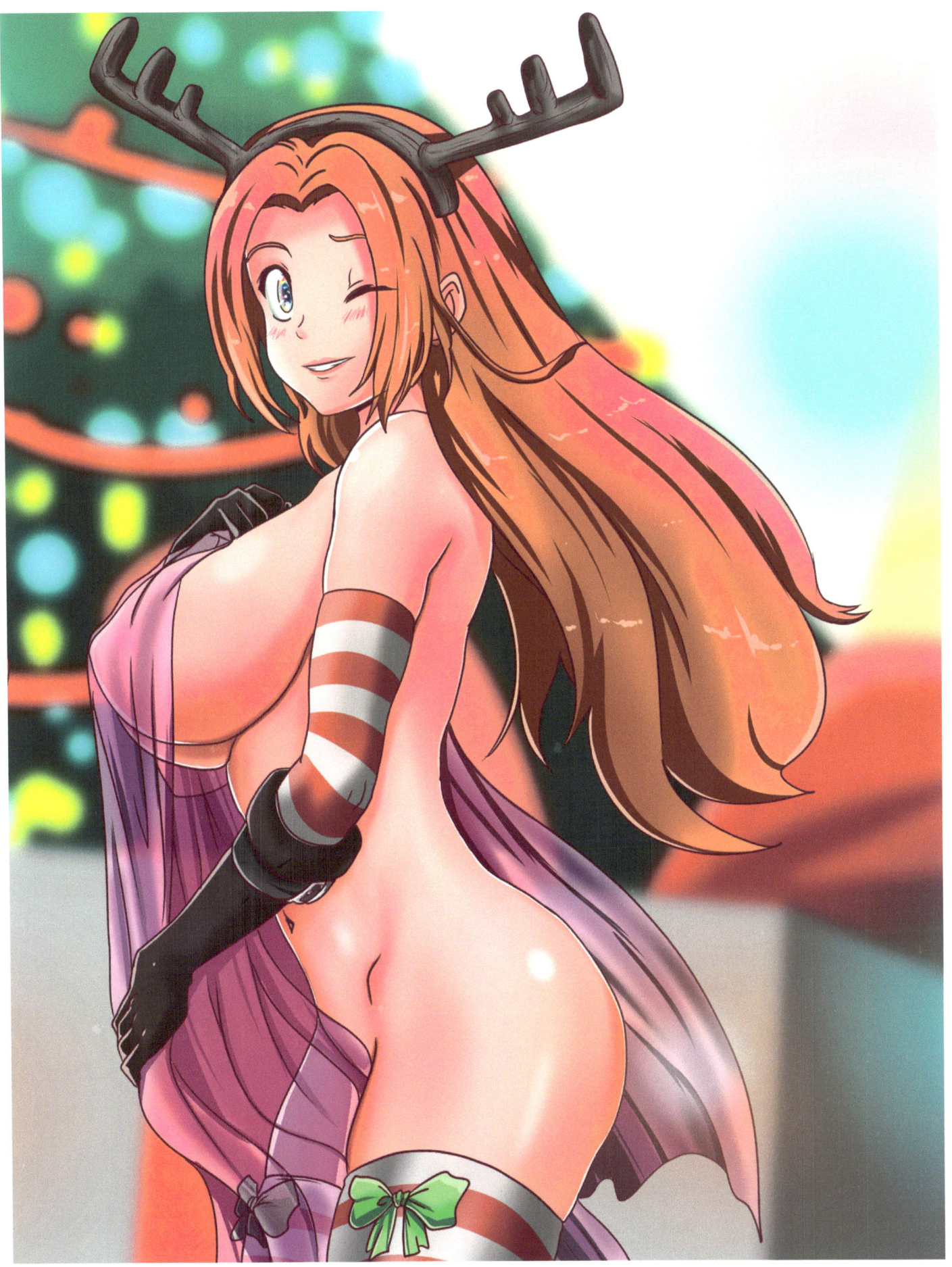

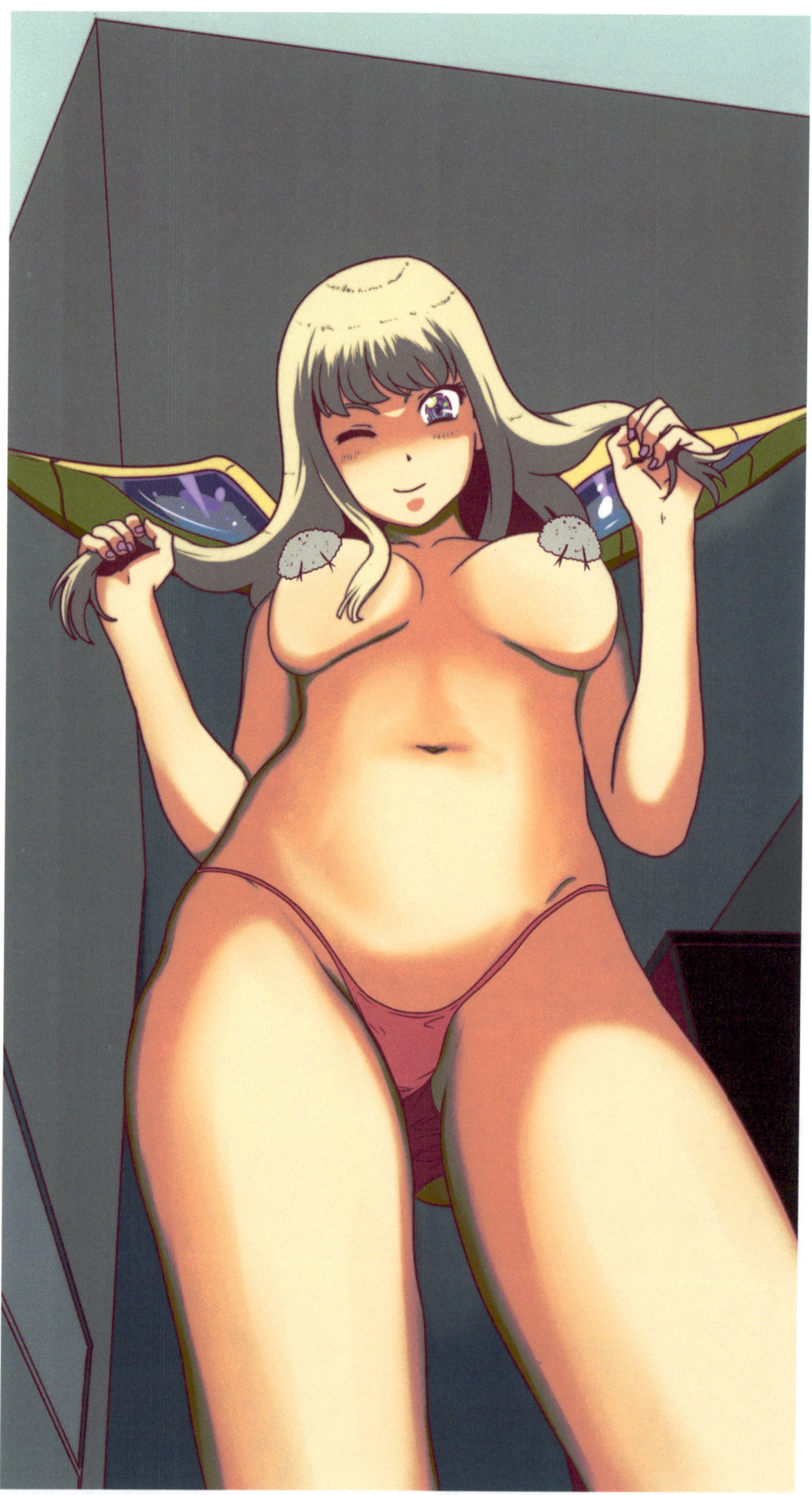

Artbook Teemovsall

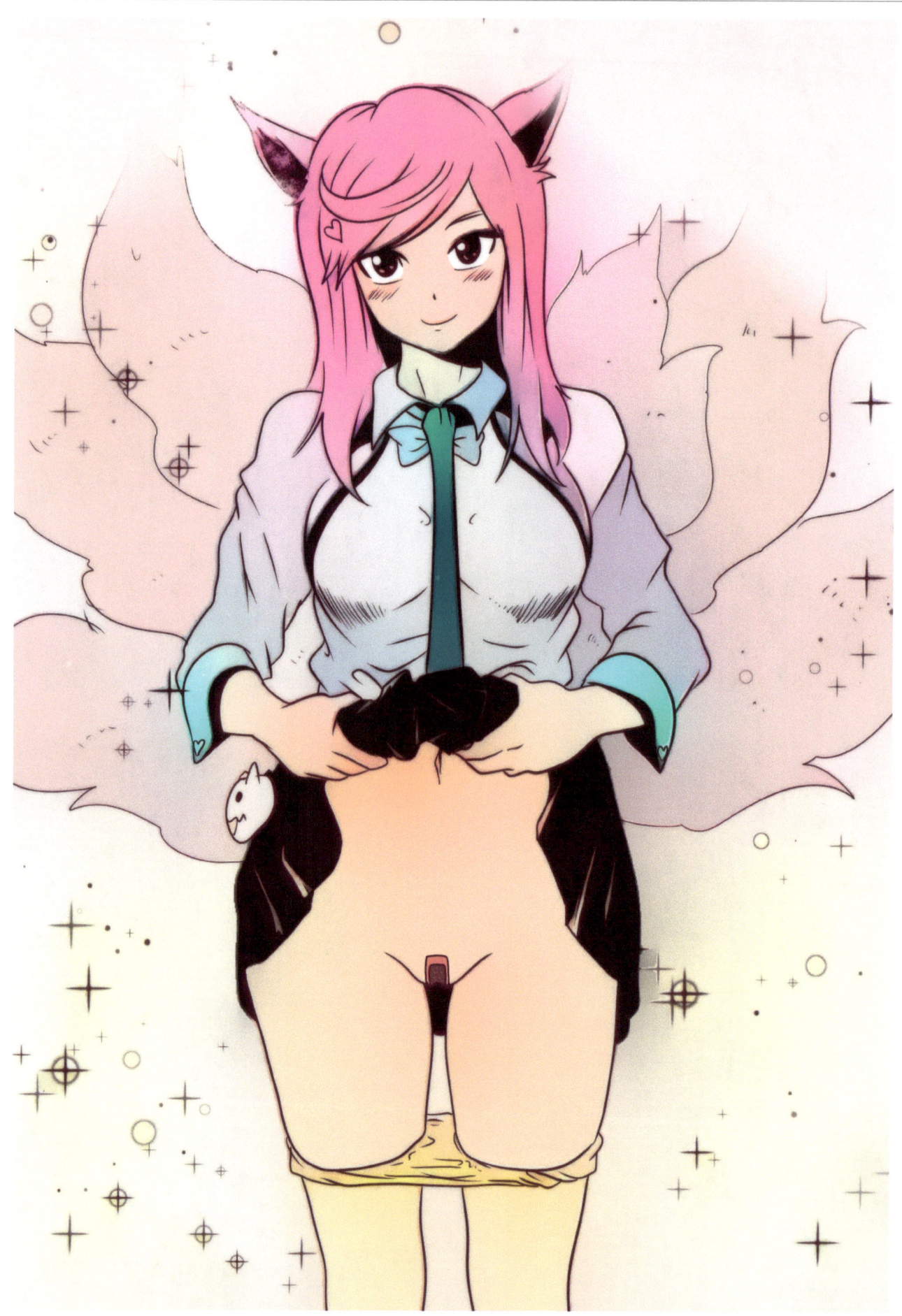

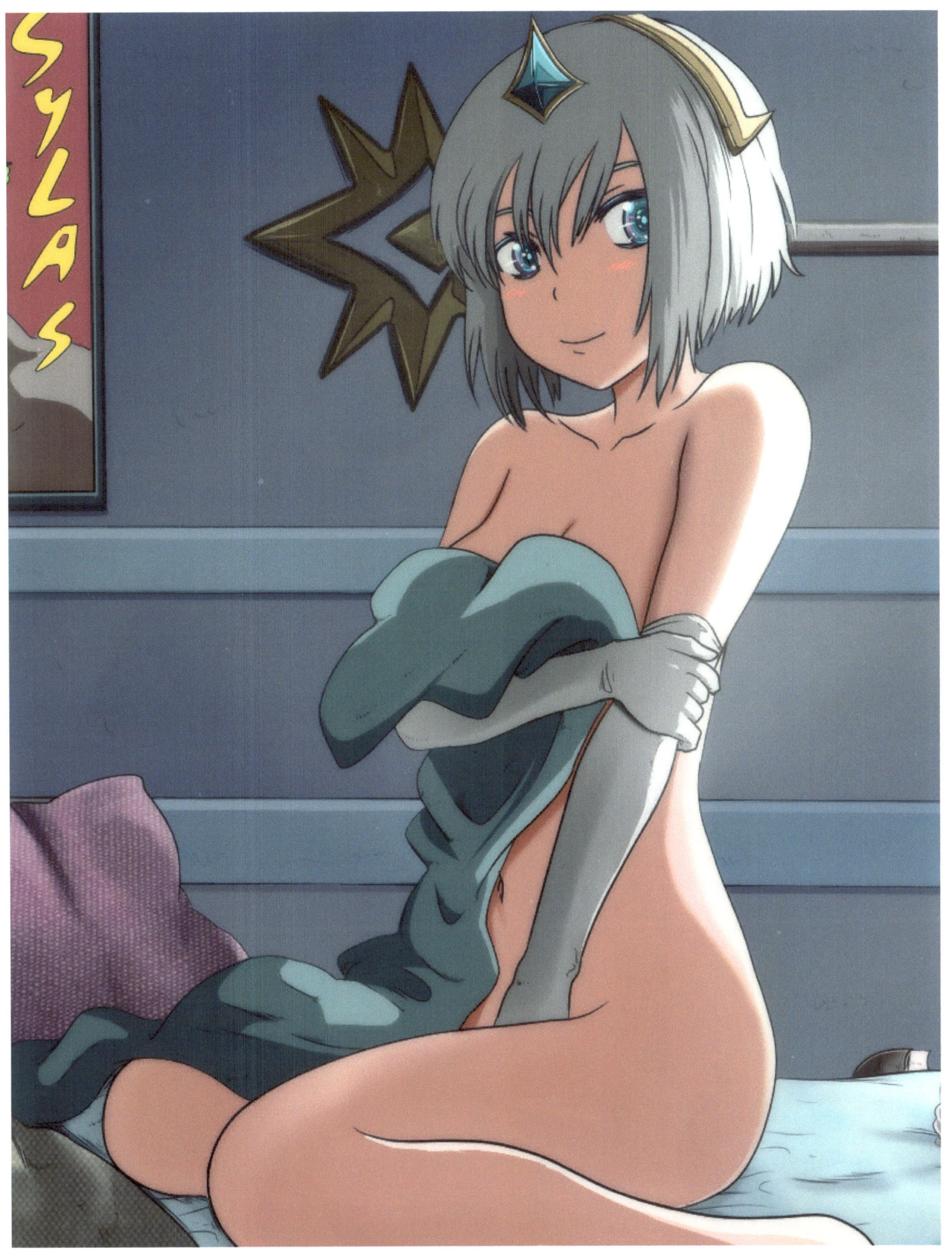

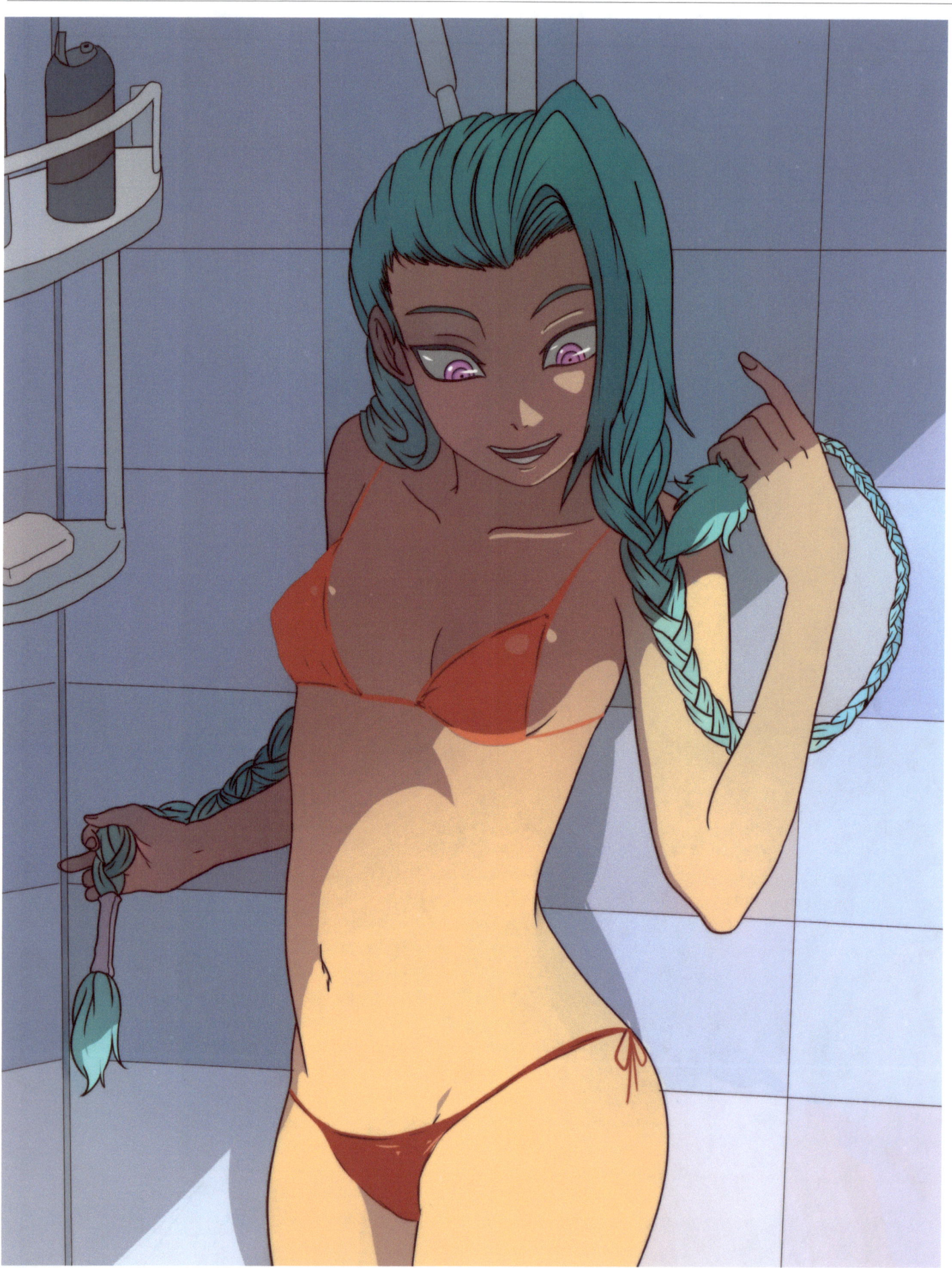

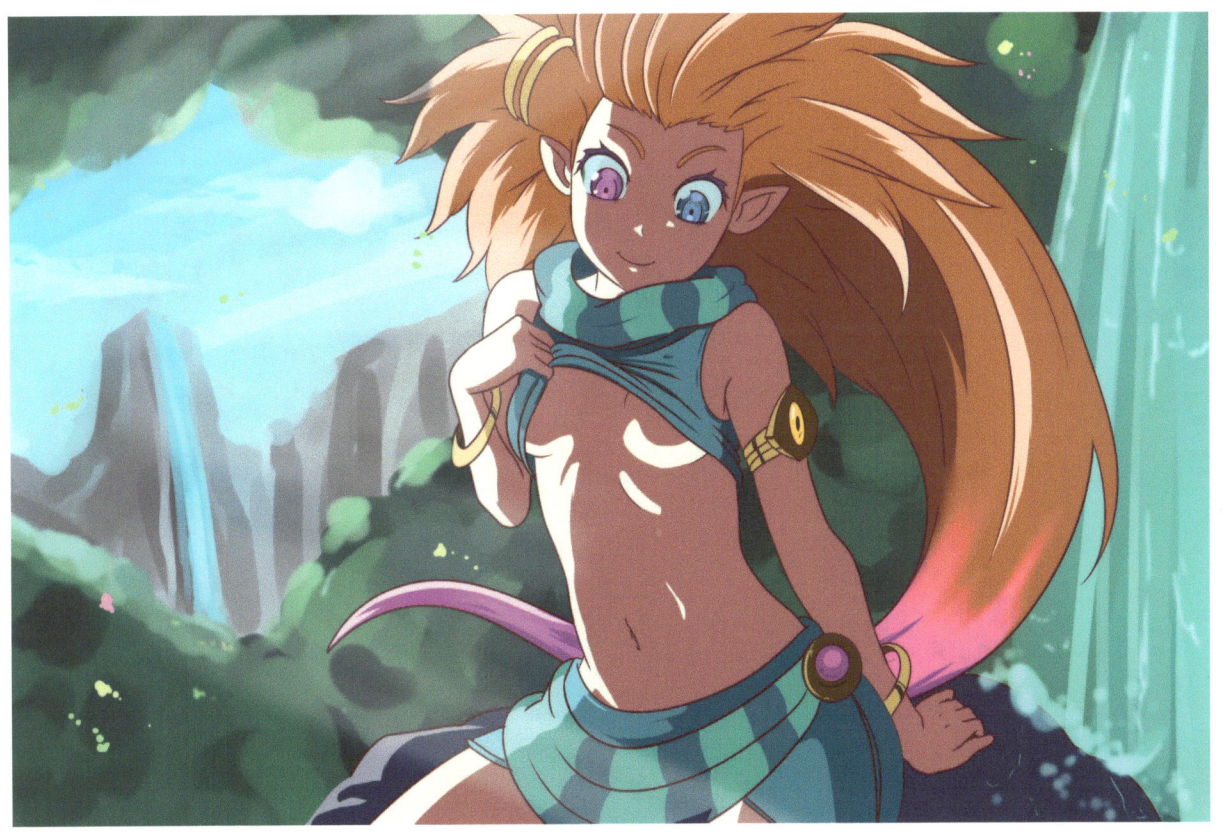

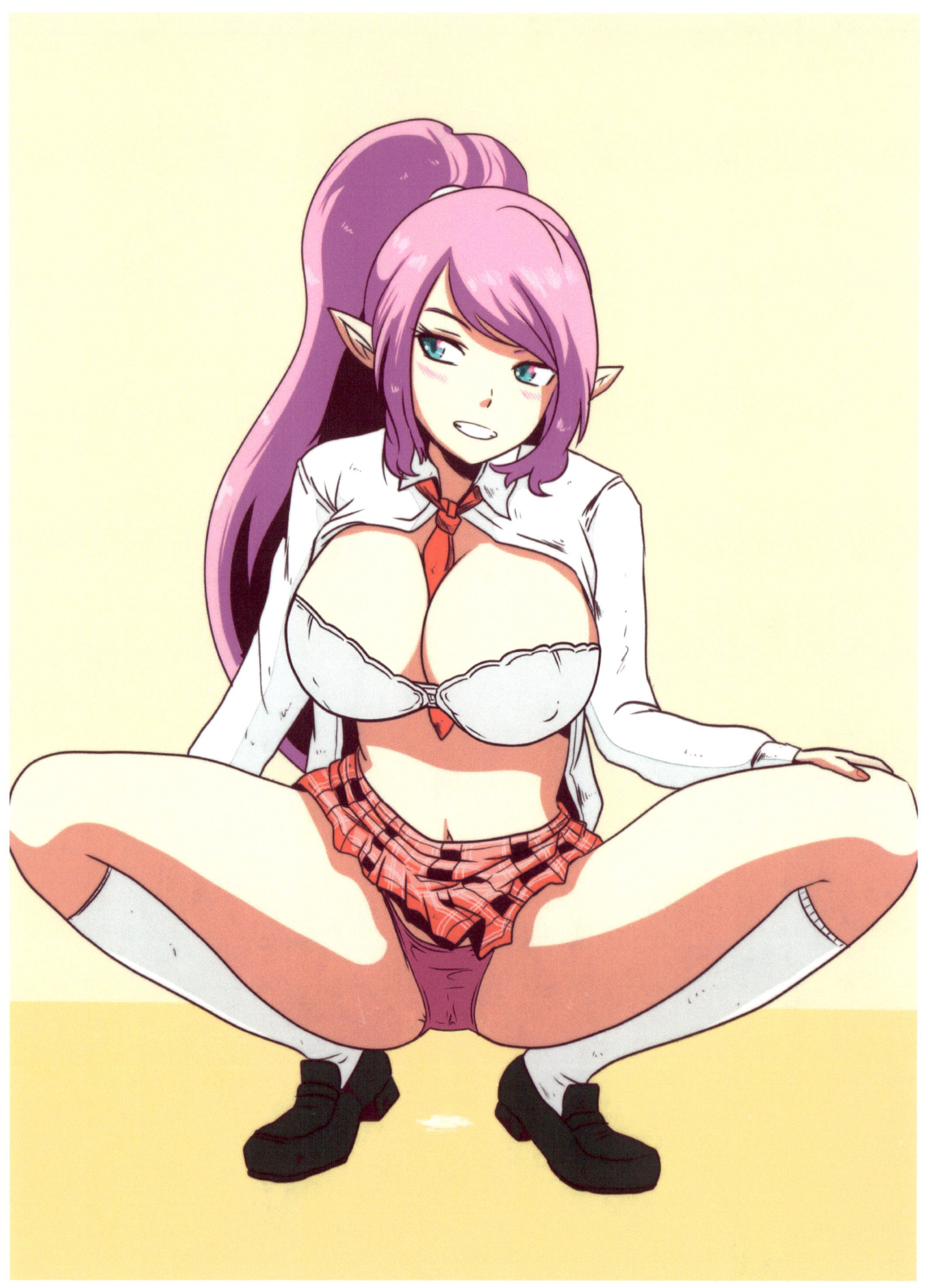

Artbook Teemovsall

Teemovsall 19

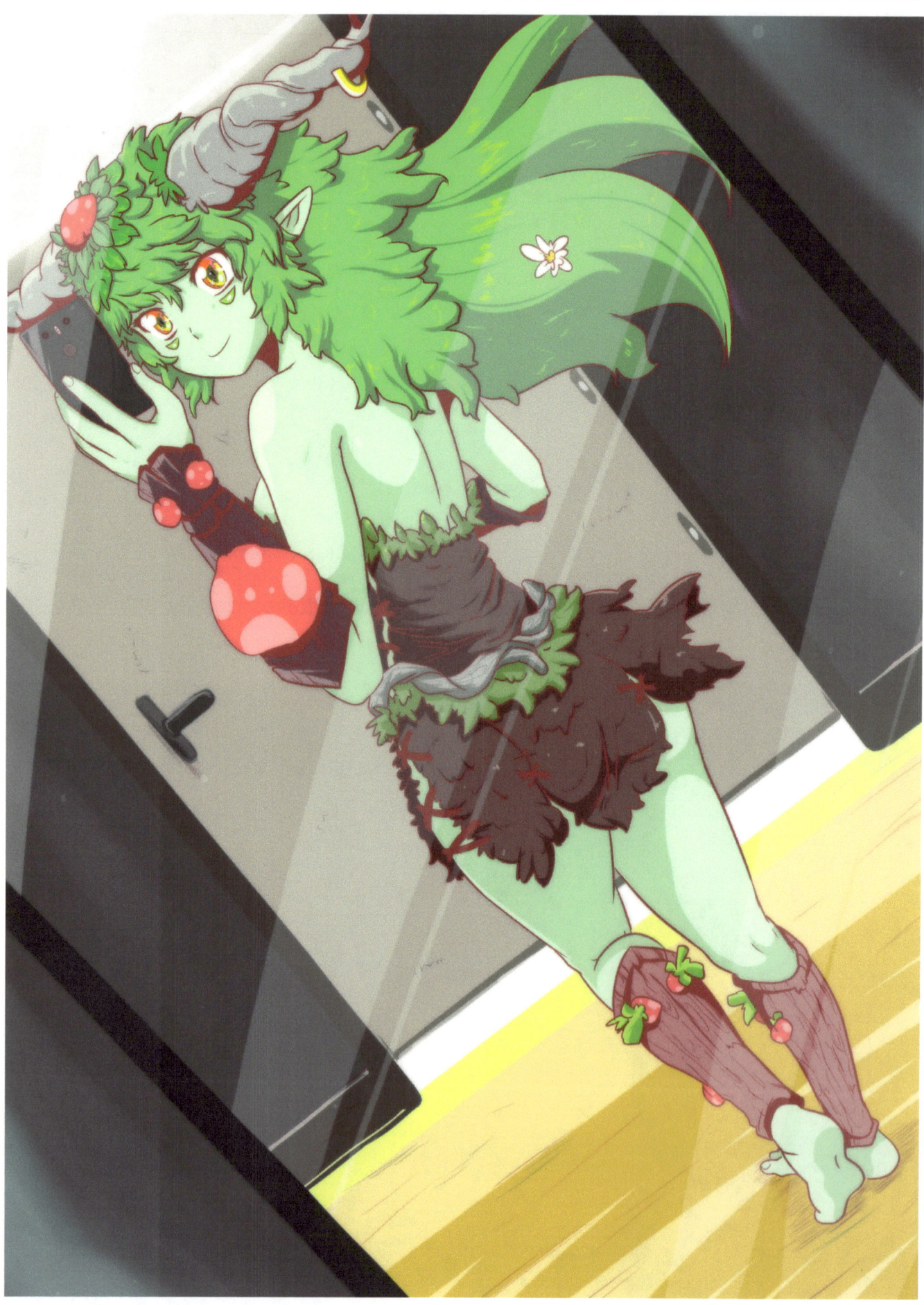

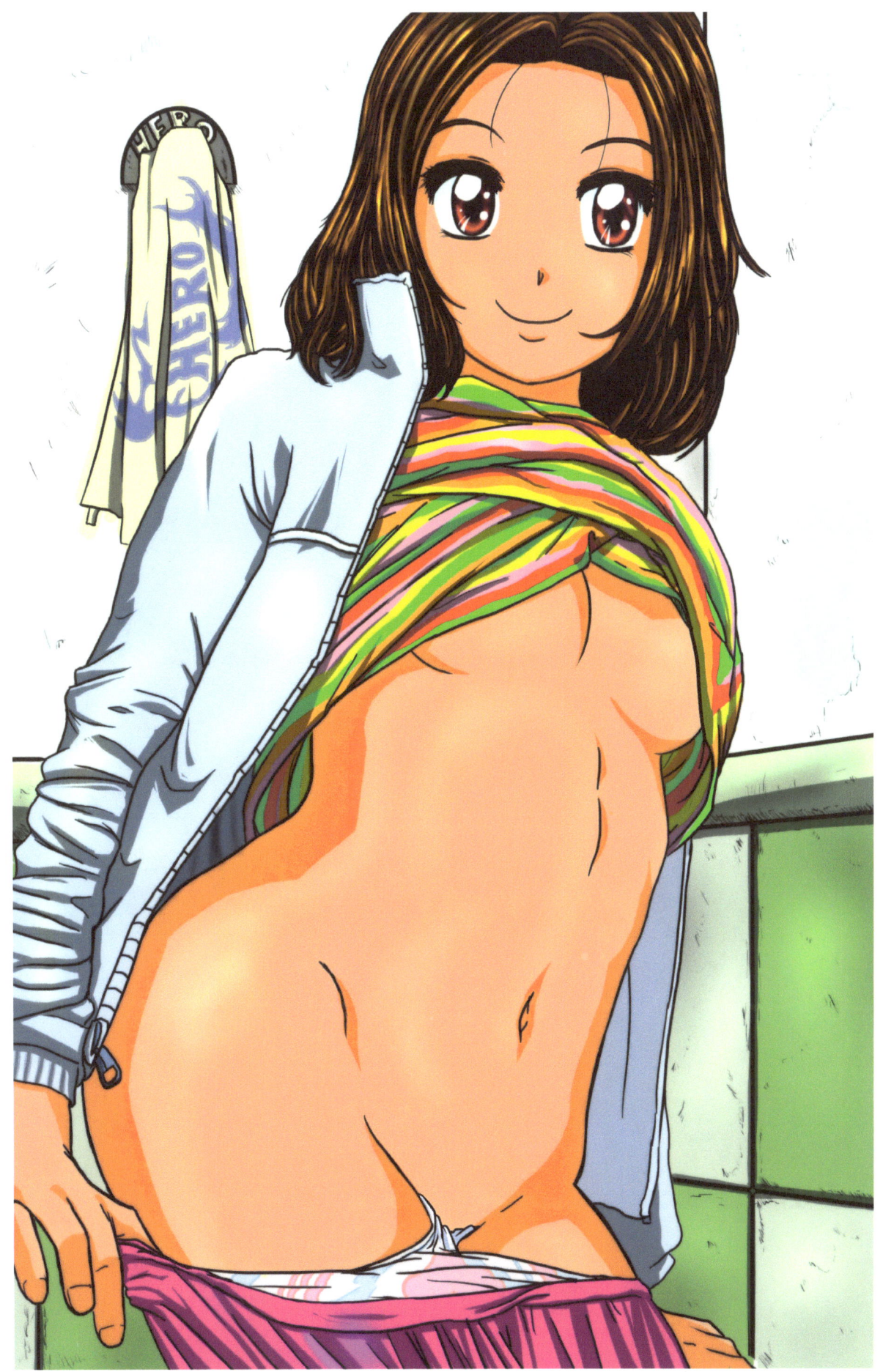

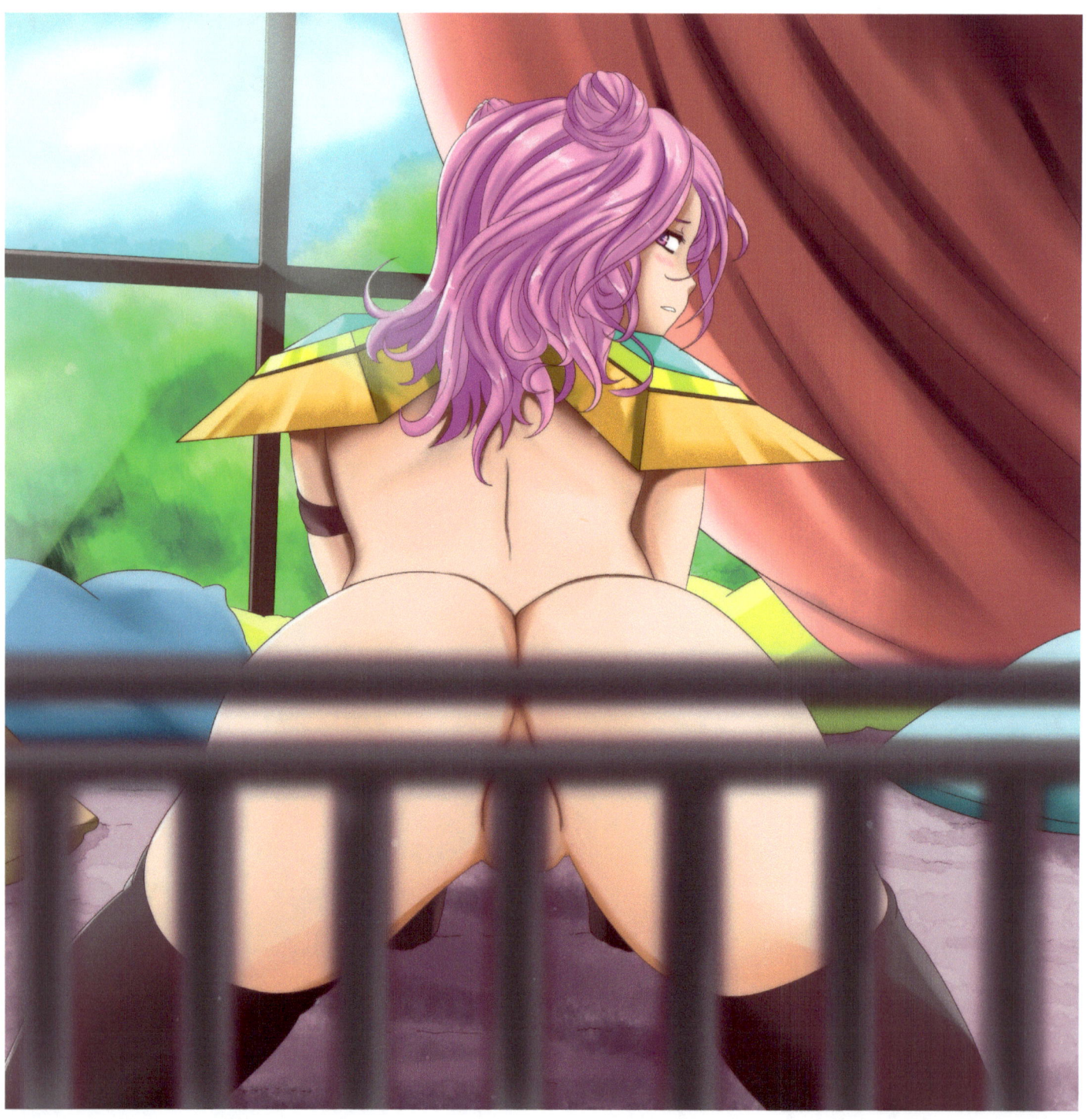

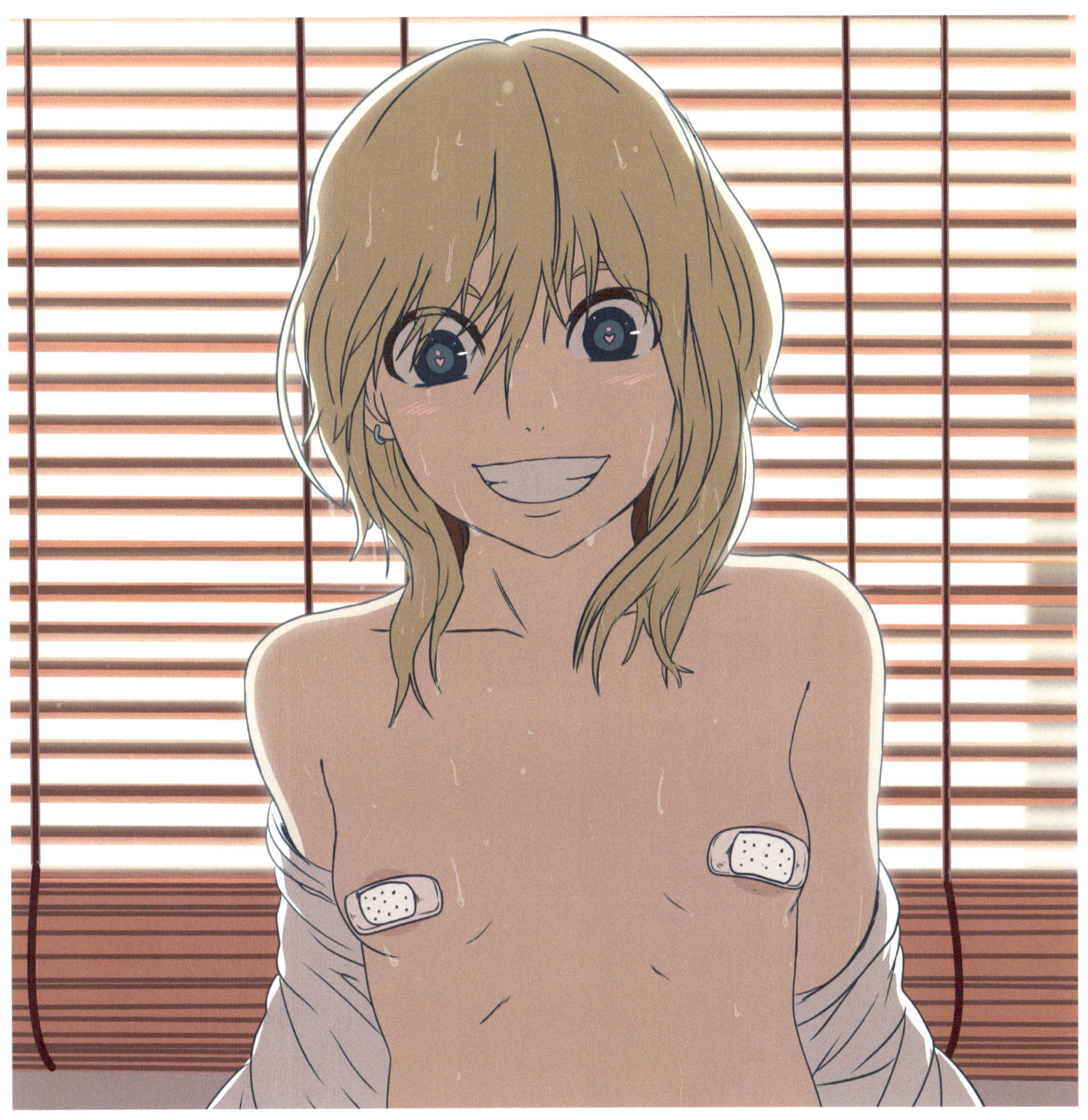

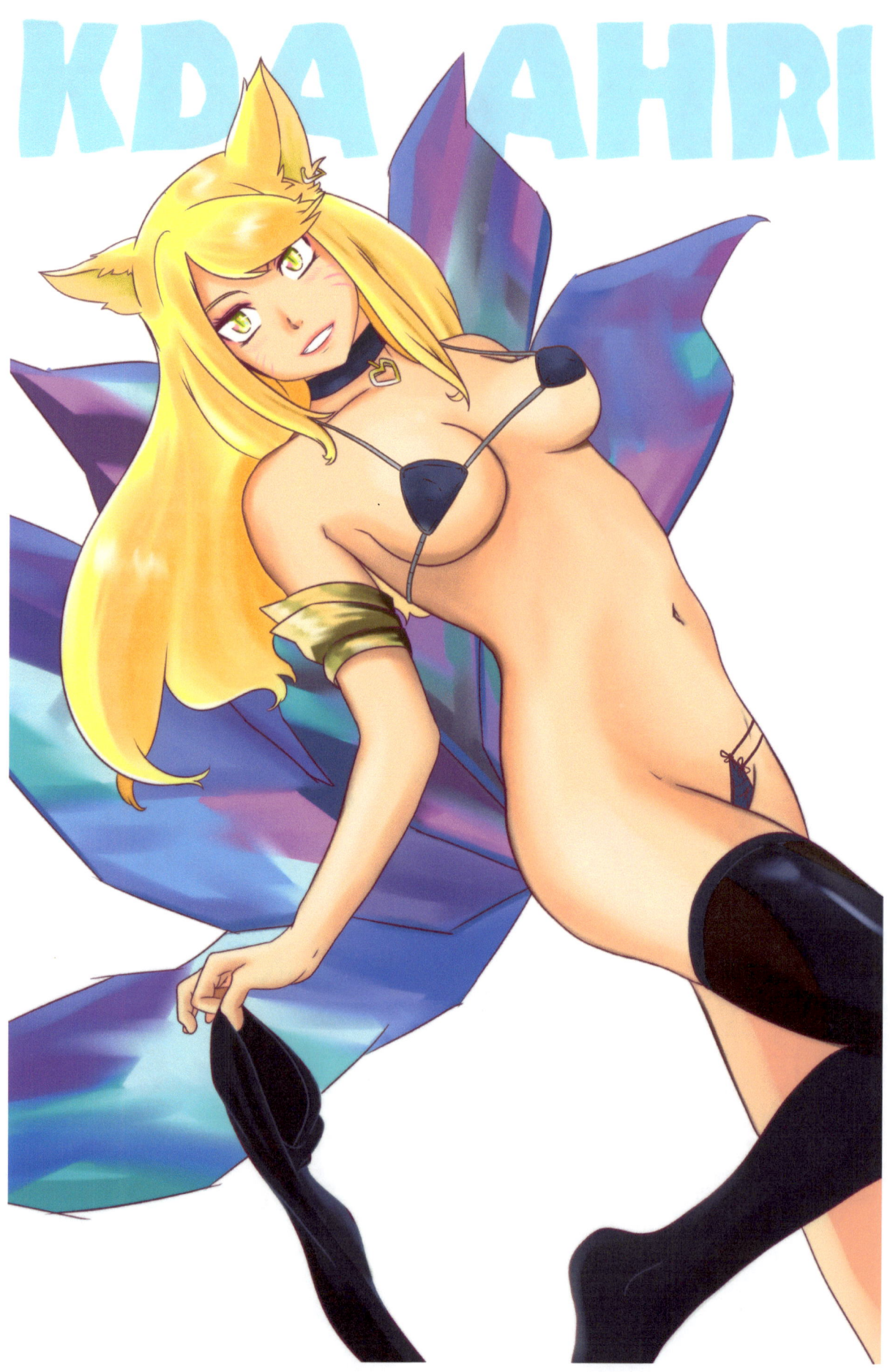

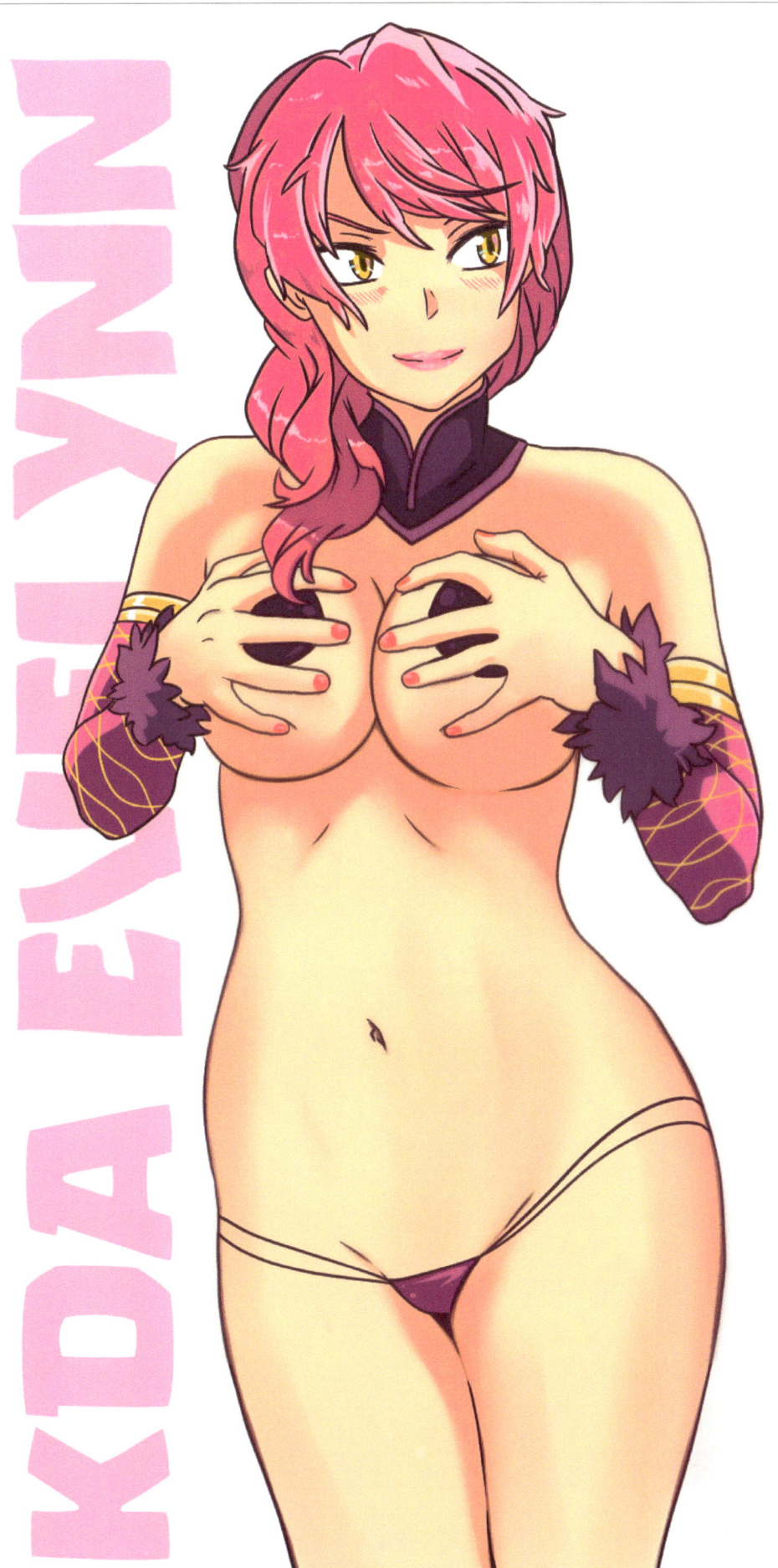

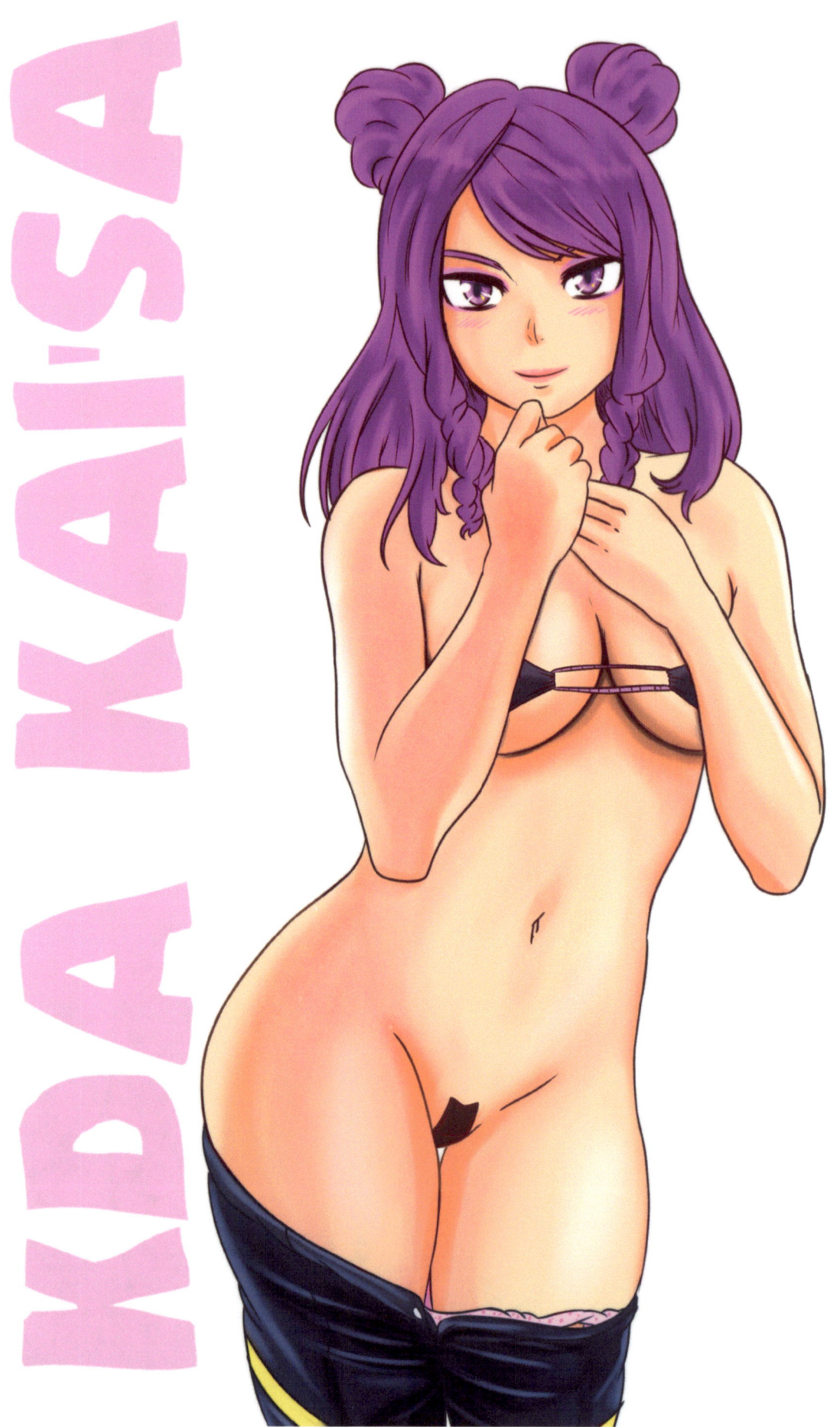

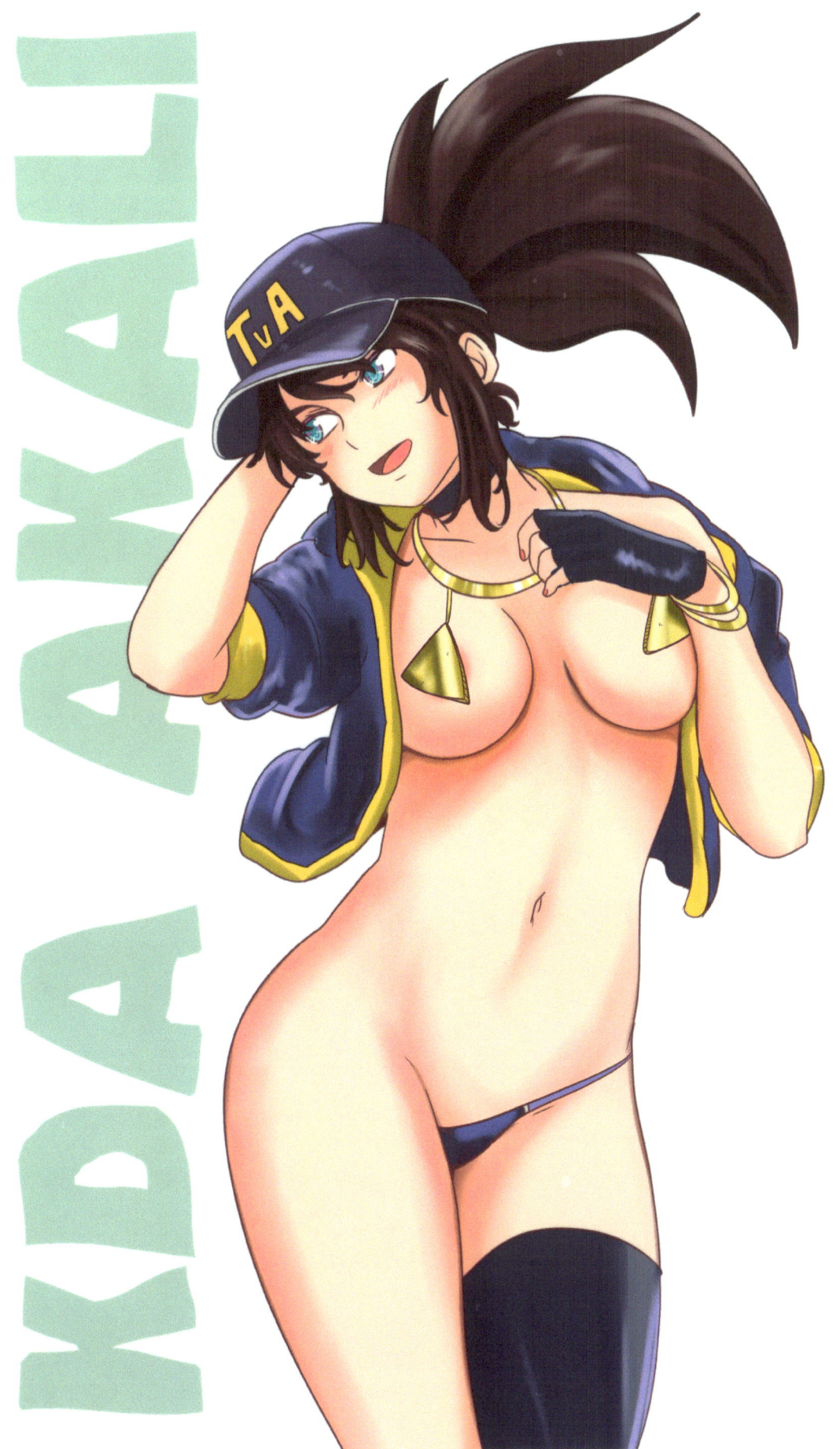

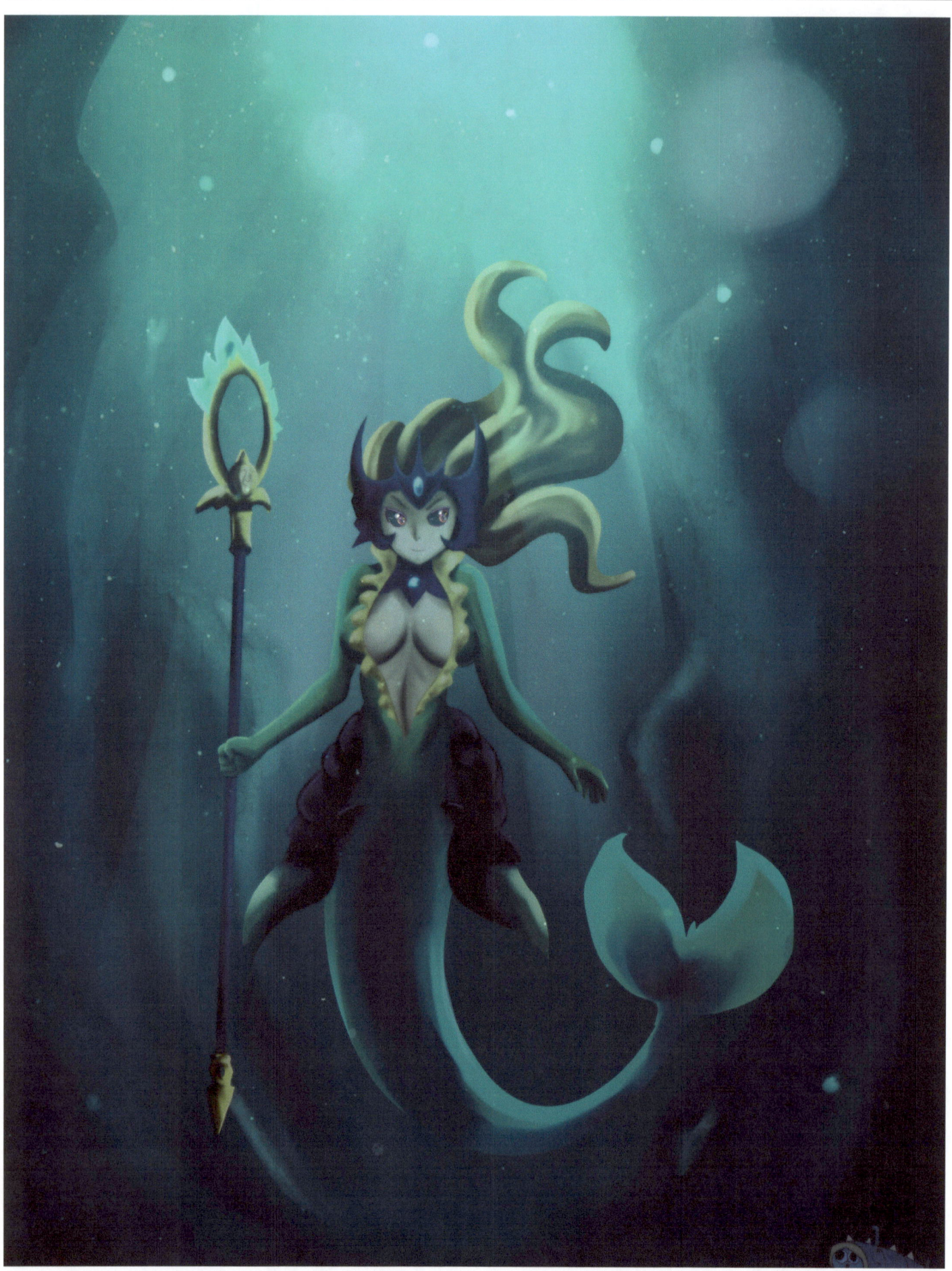

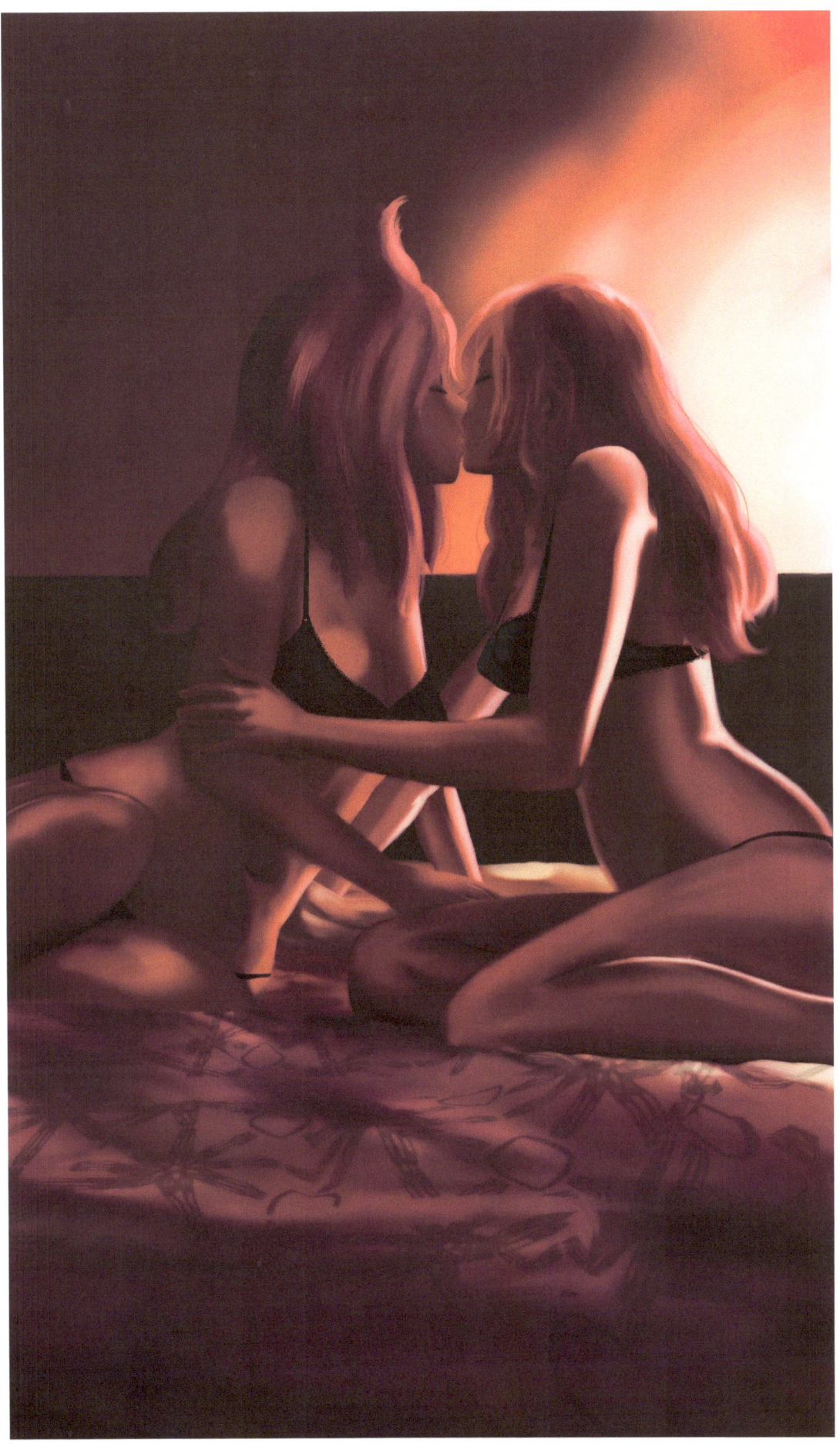

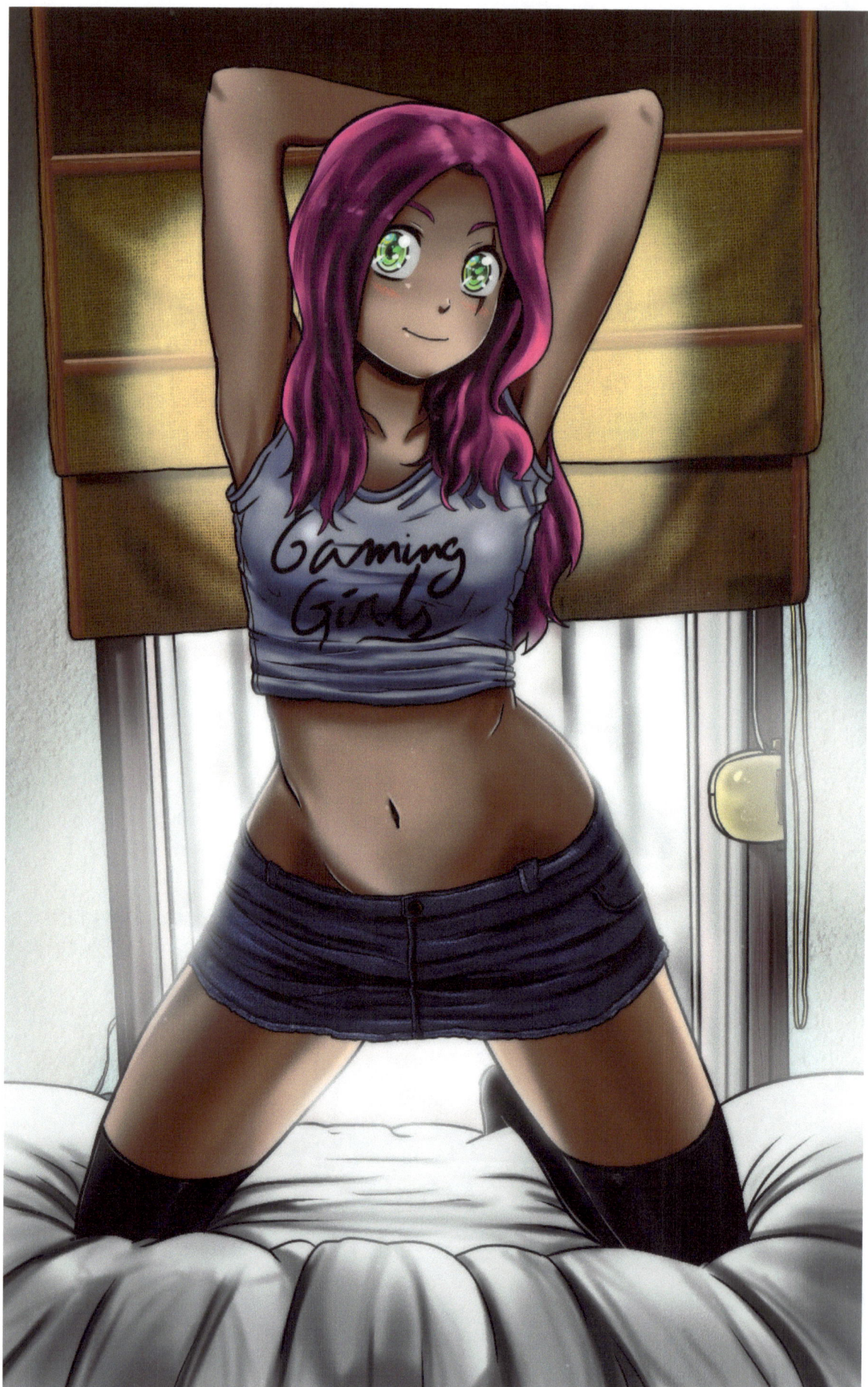

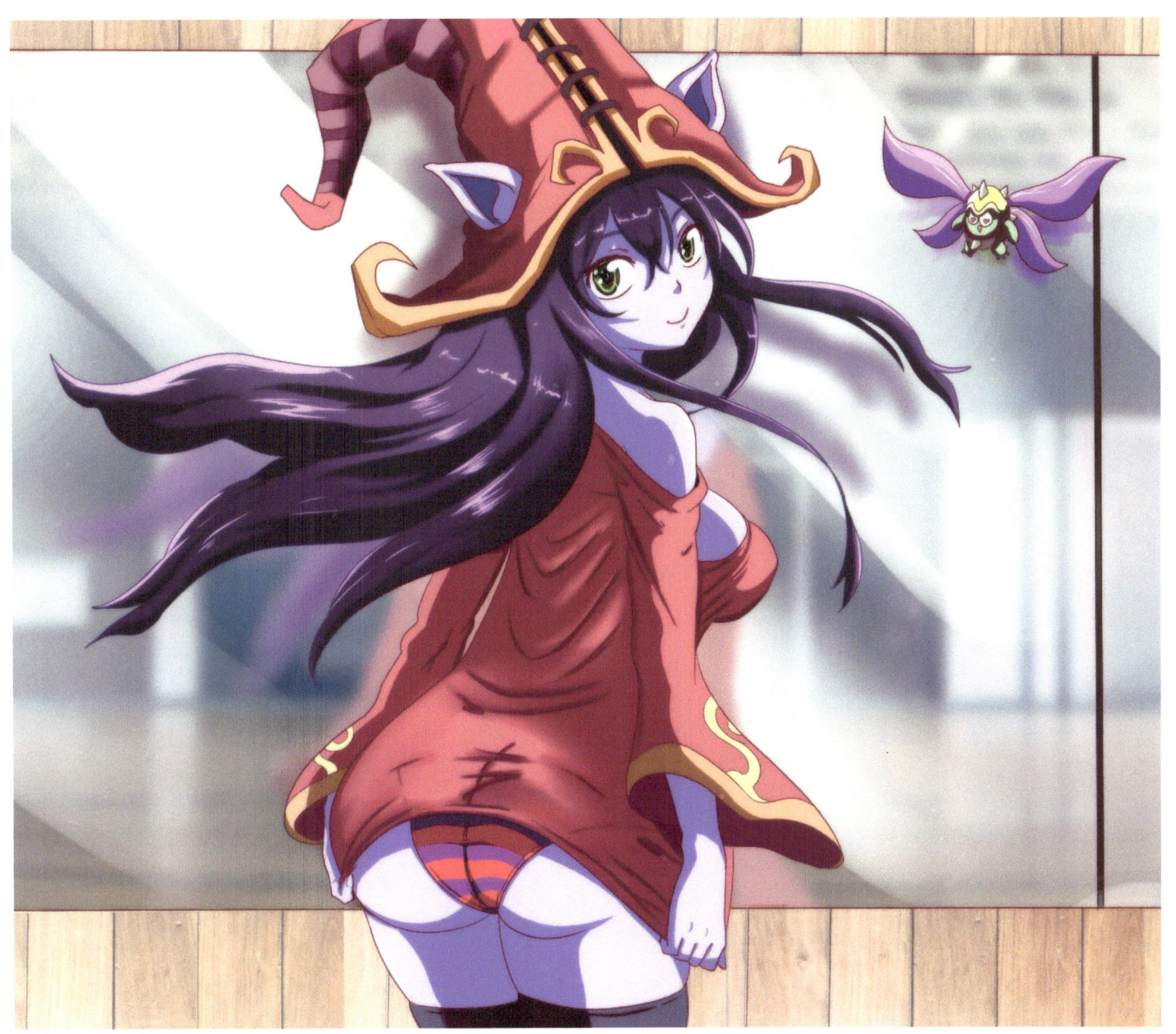

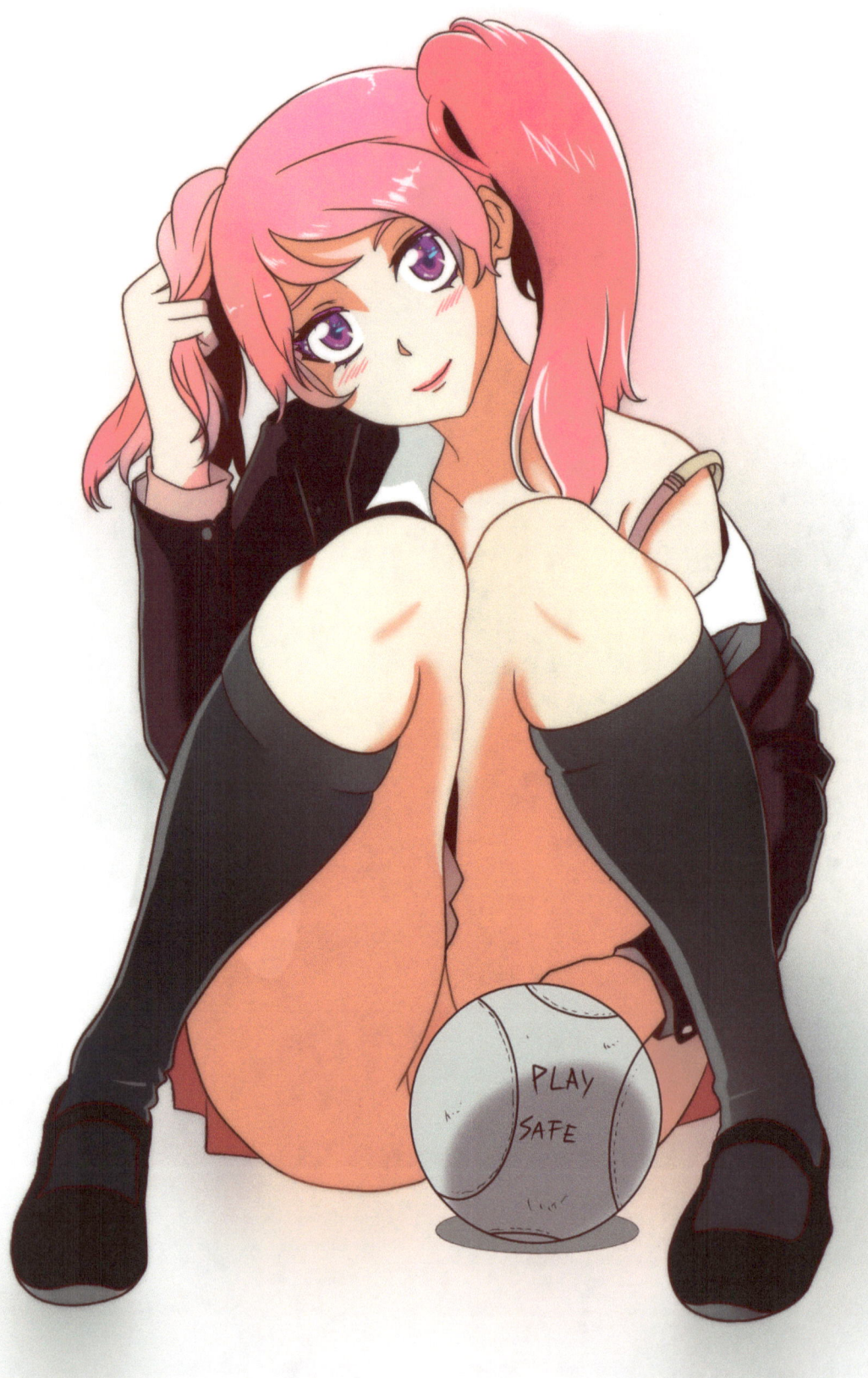

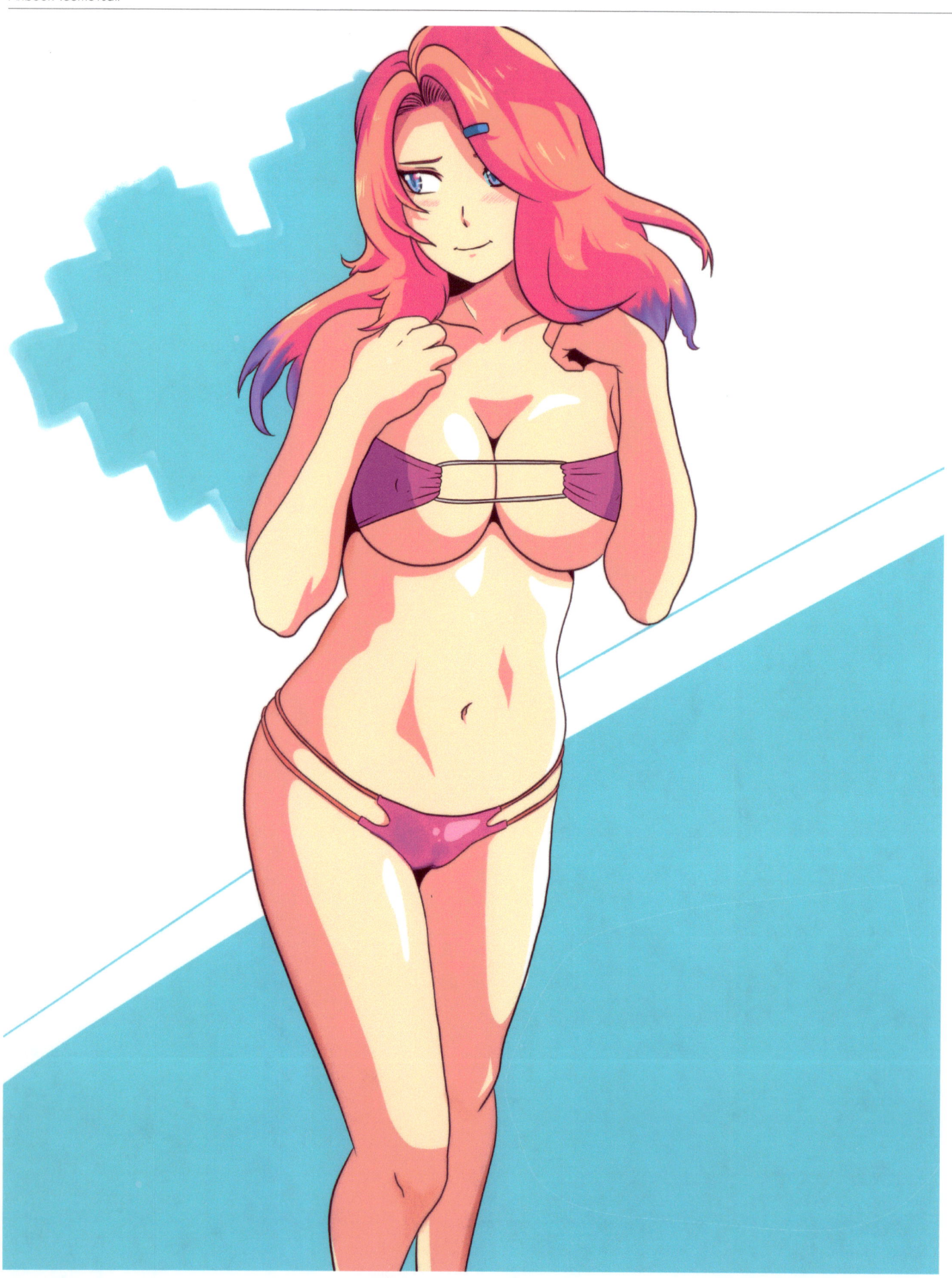

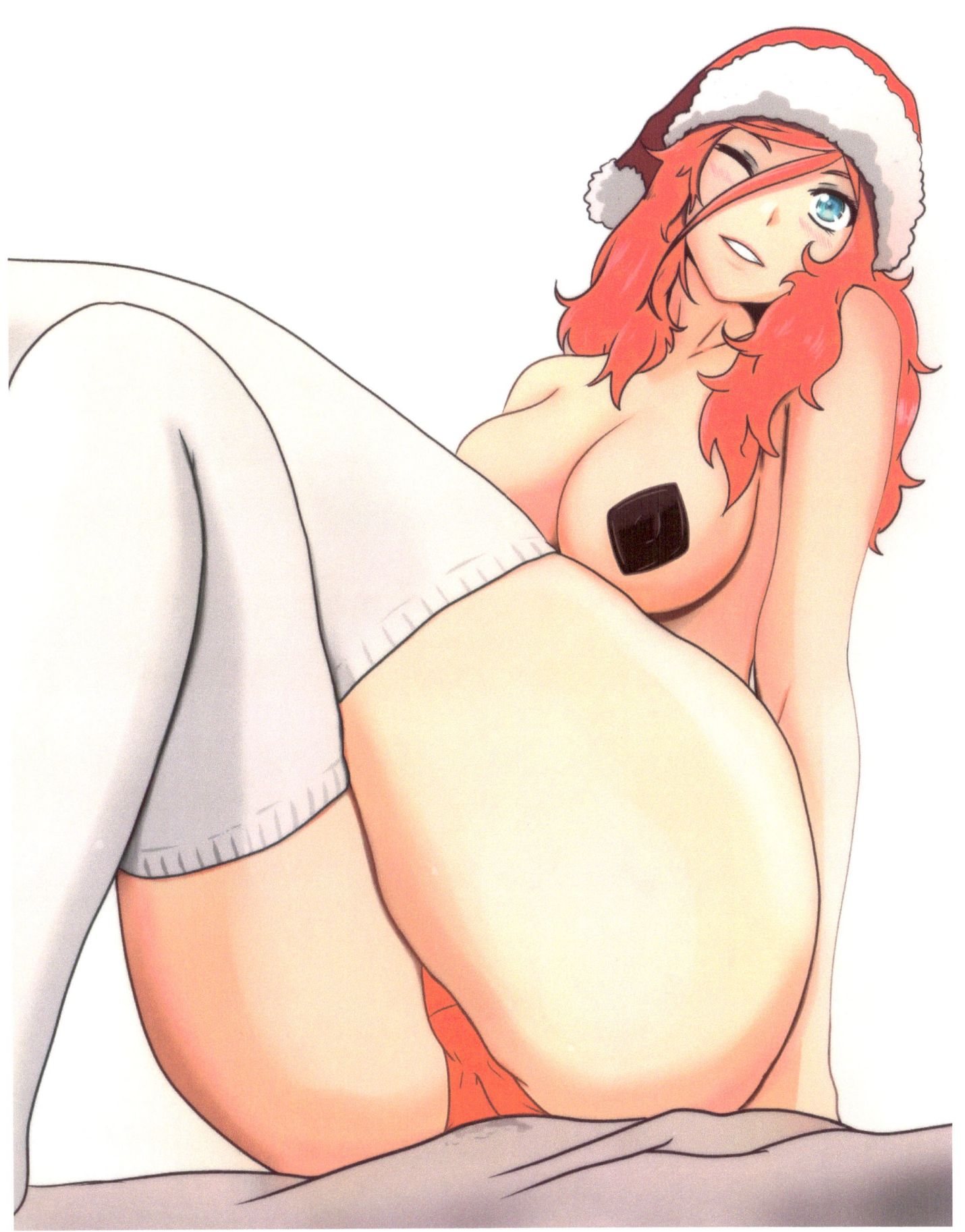

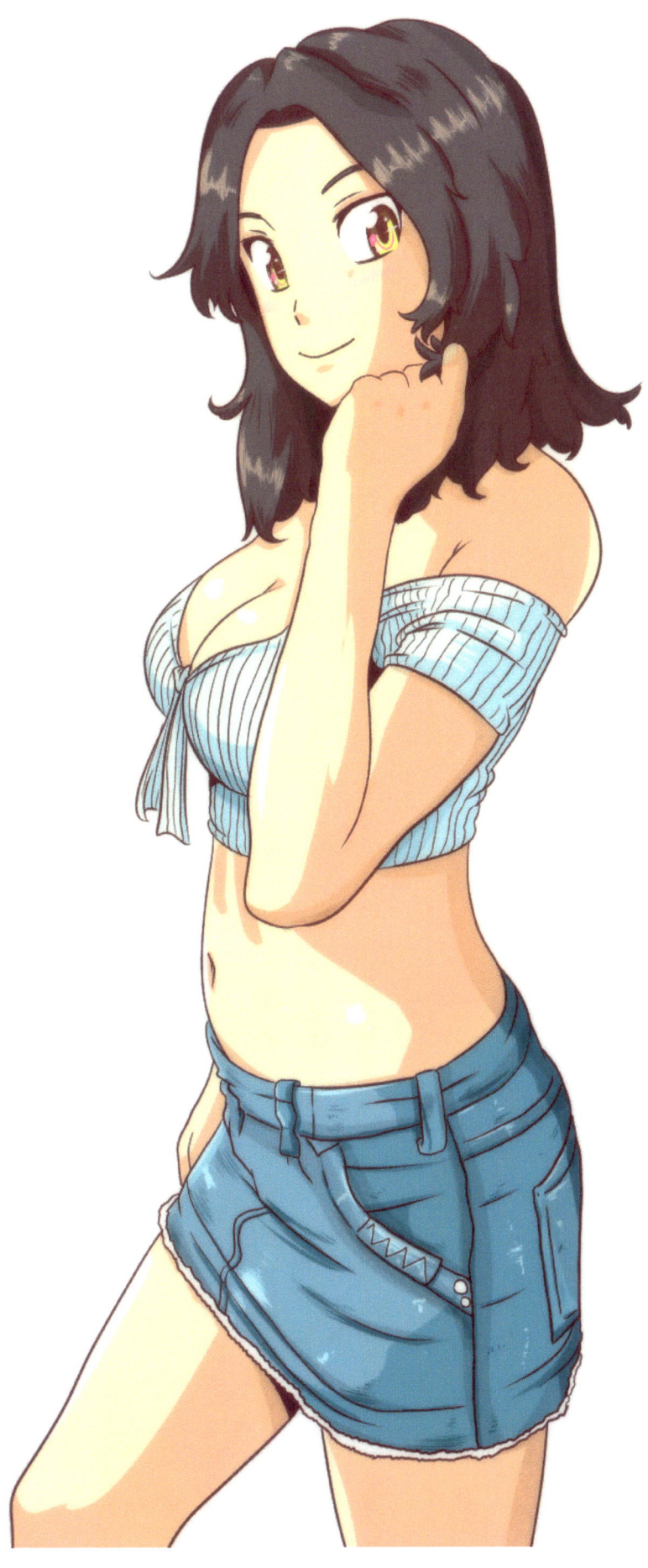

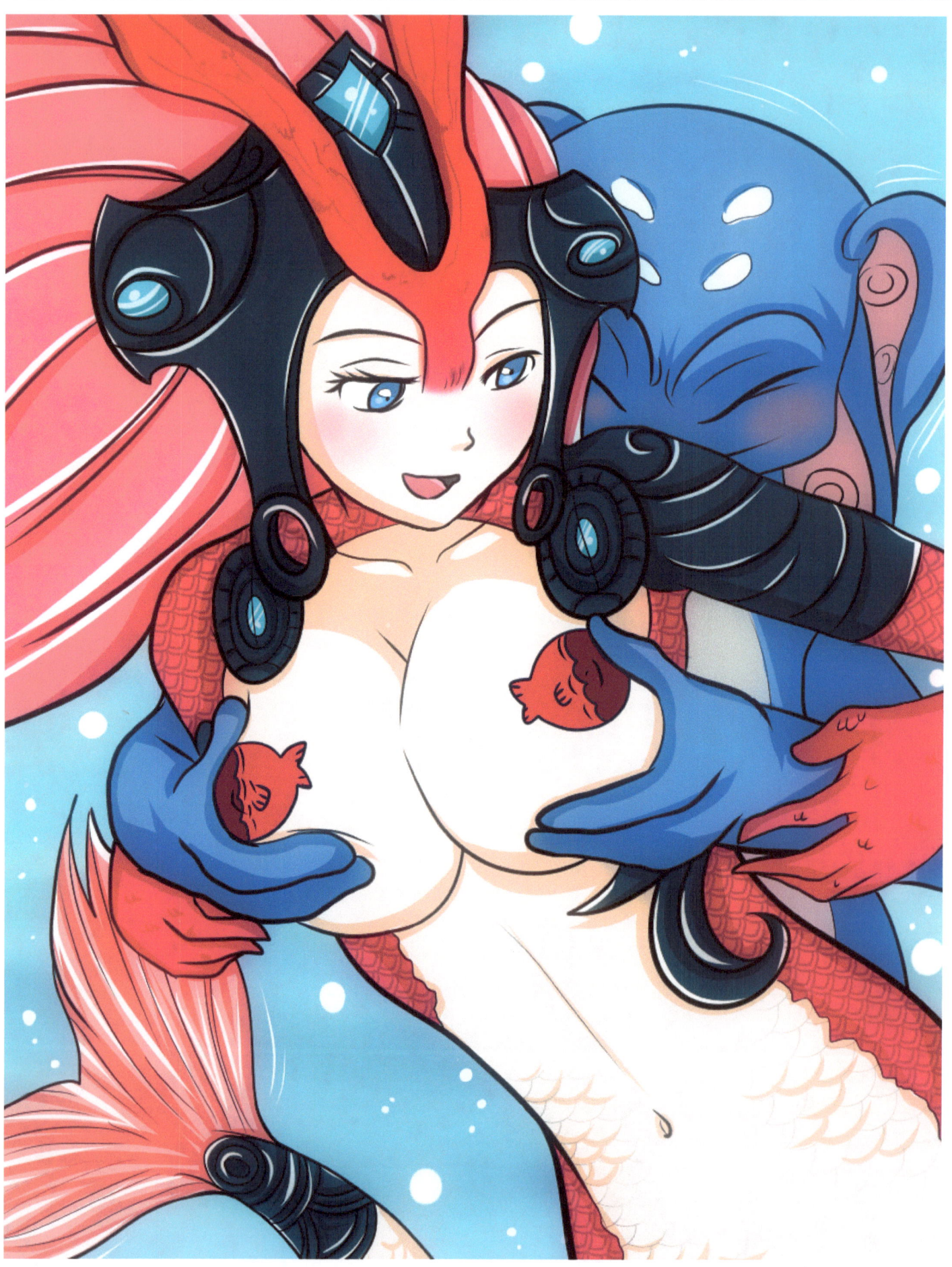

Artbook Teemovsall

Teemovsall 39

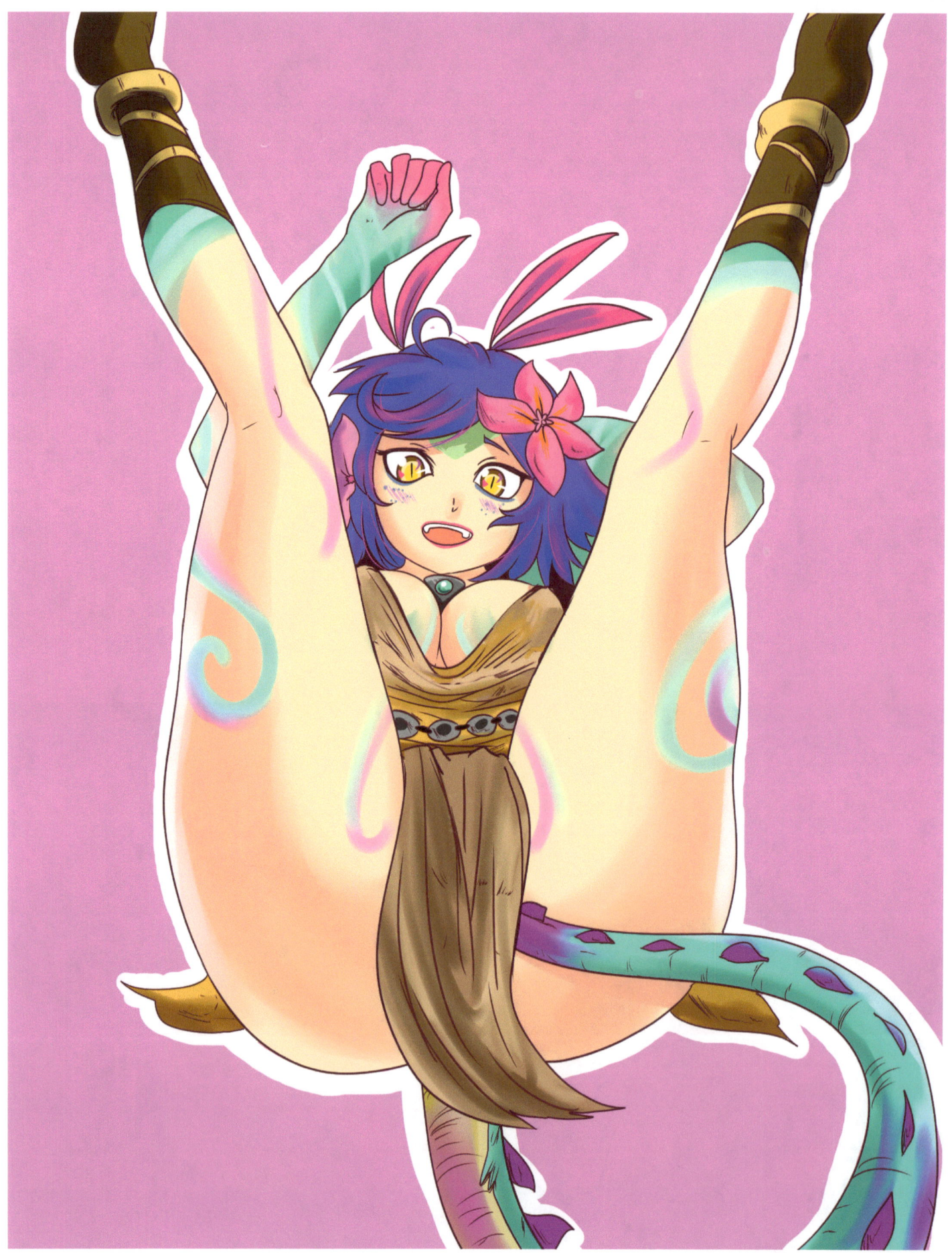

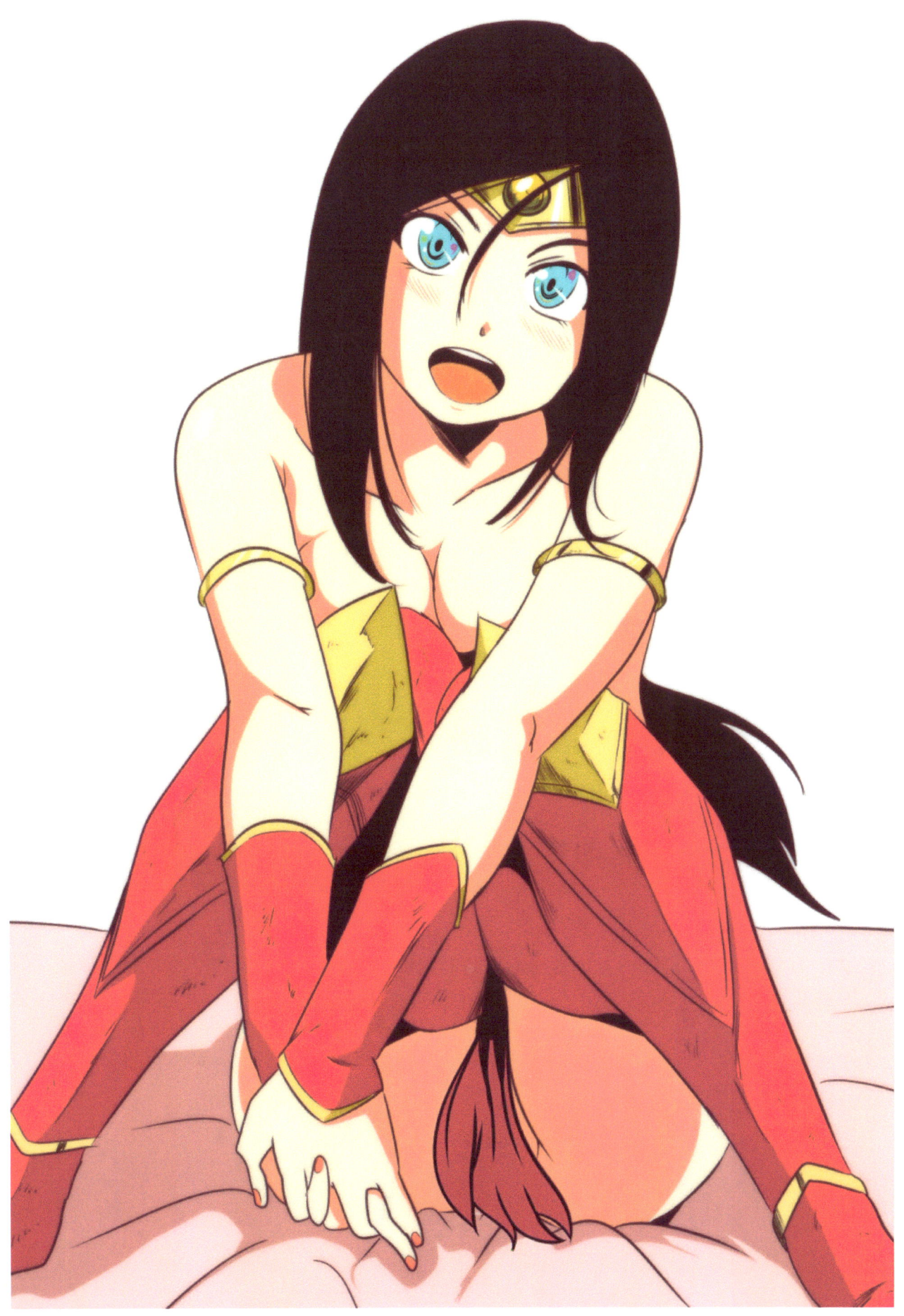

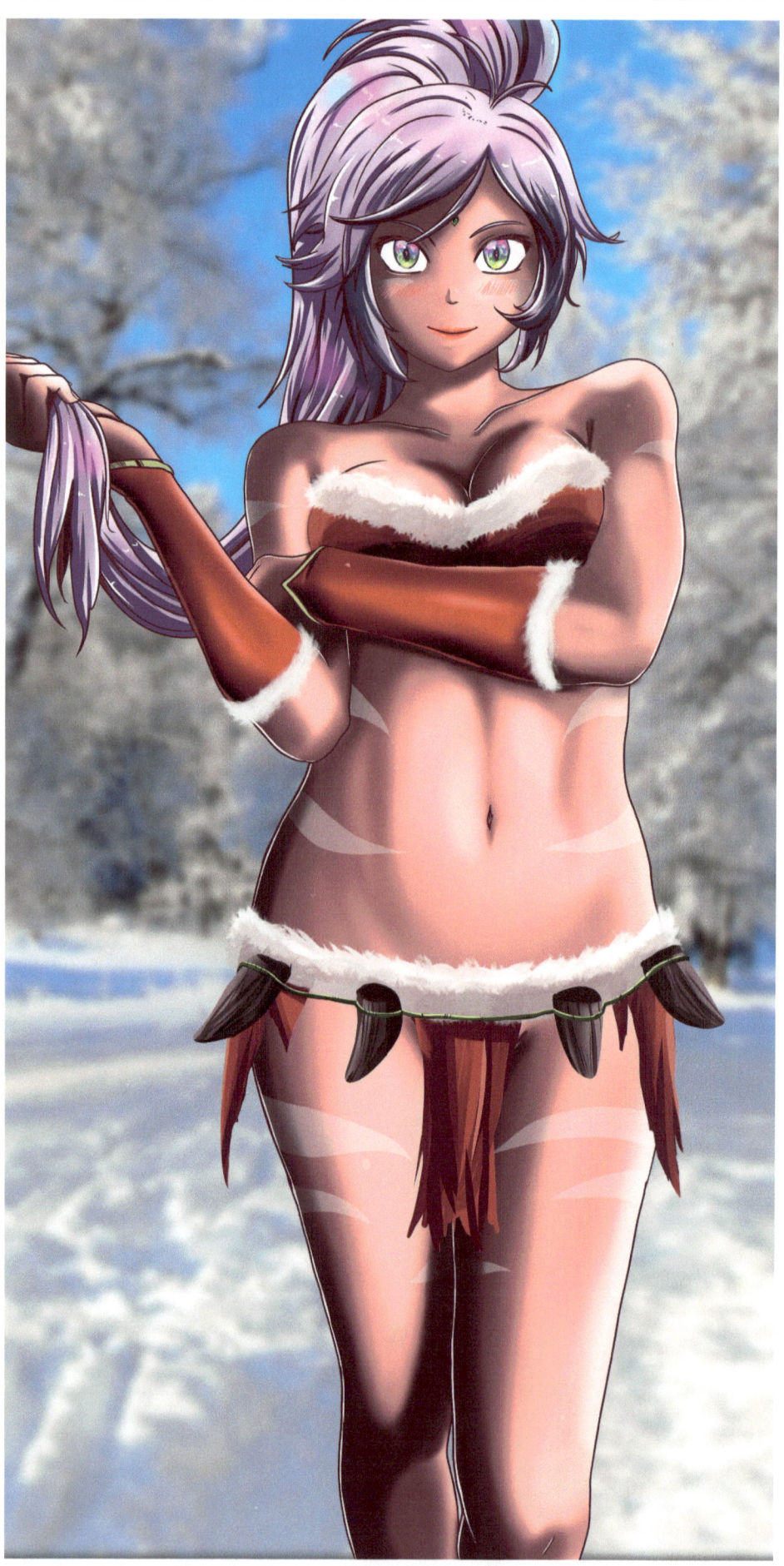

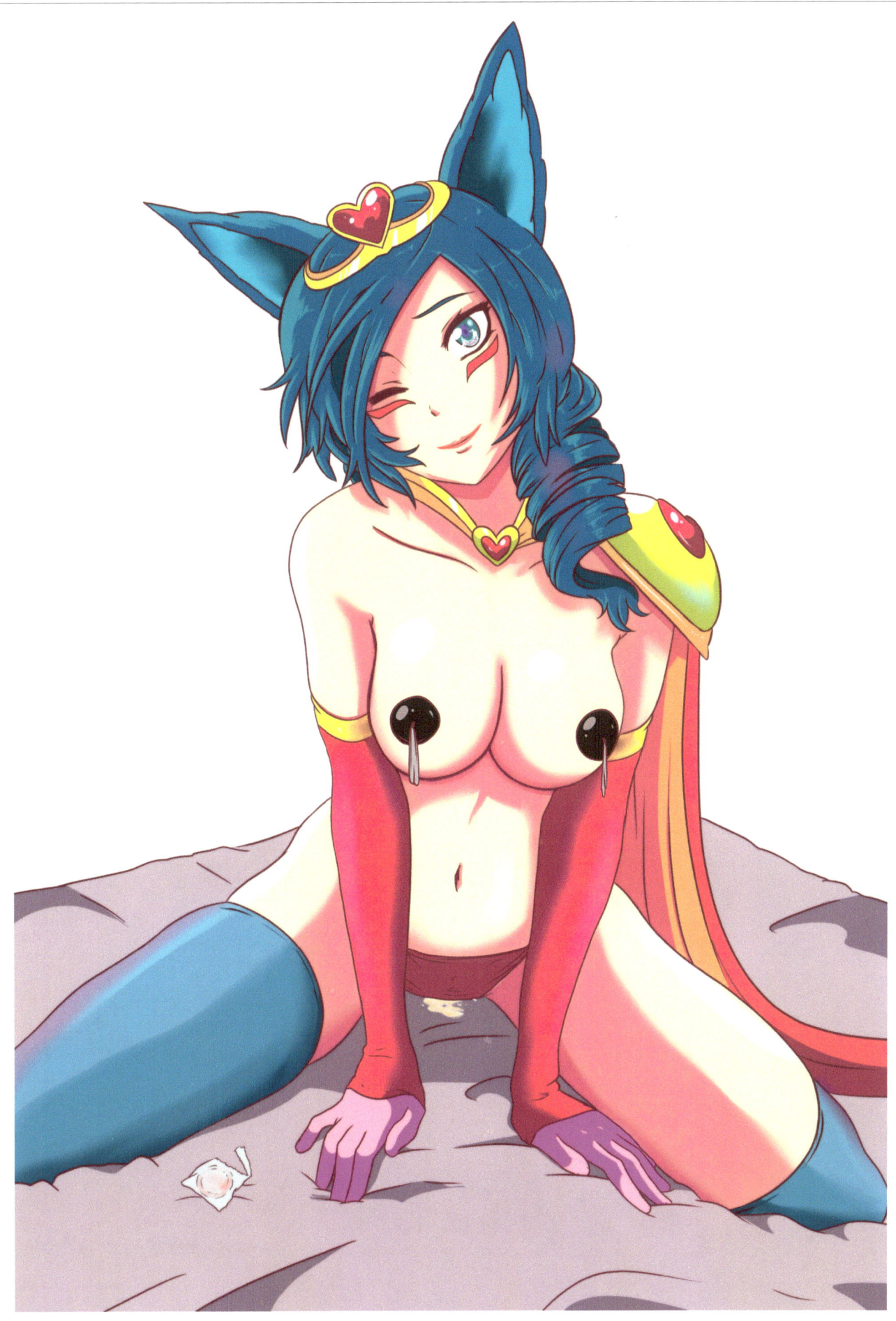

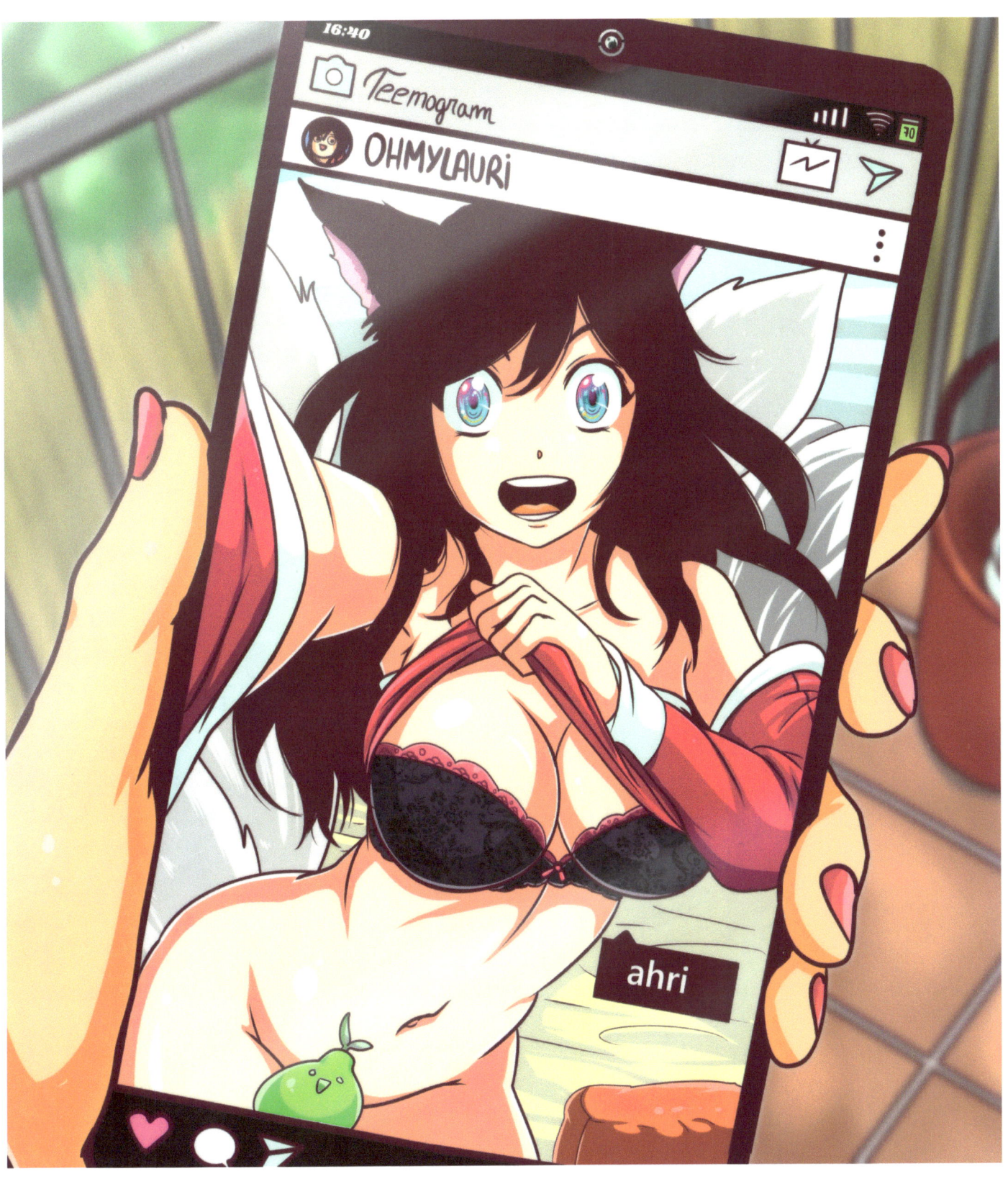

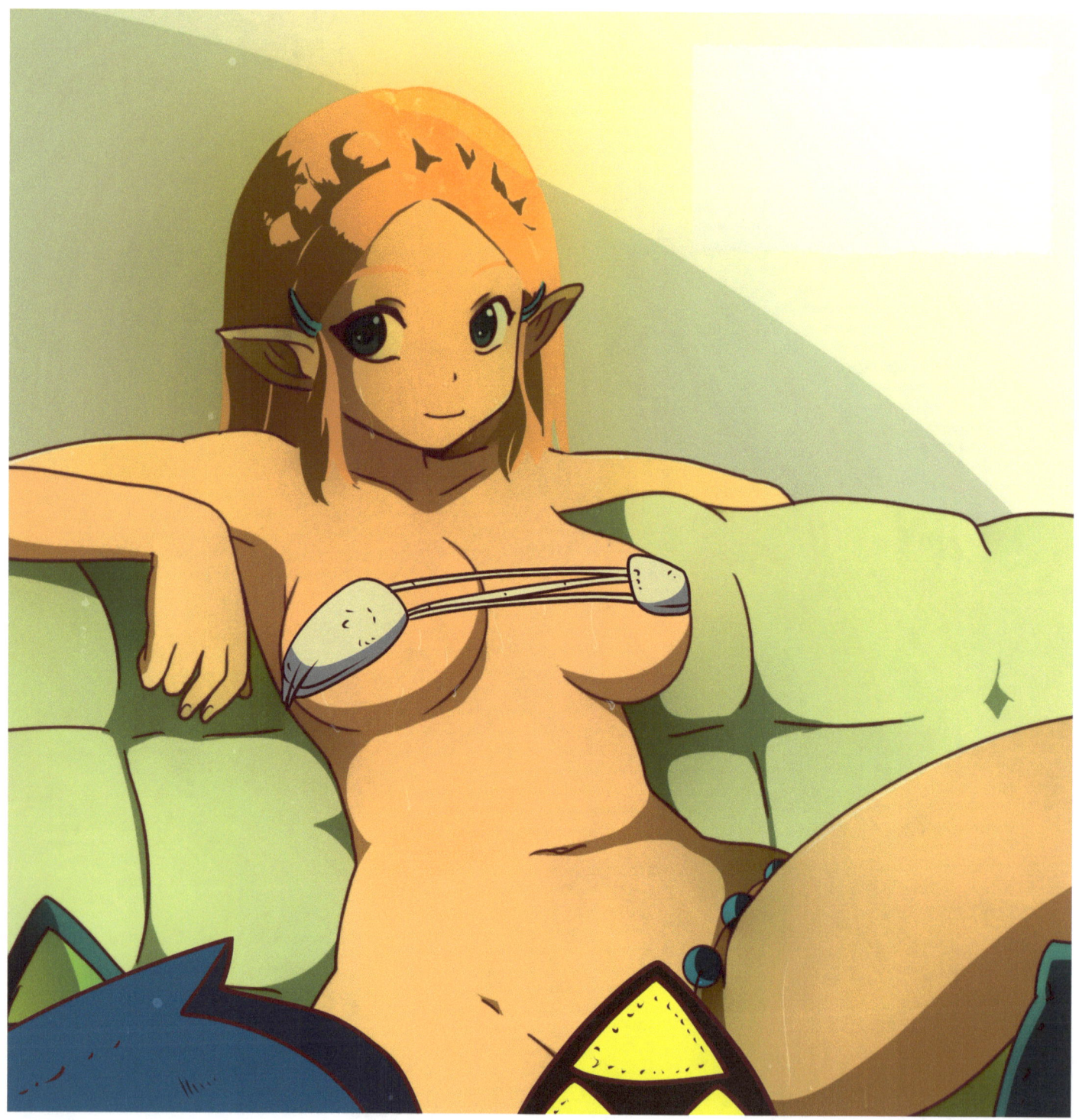

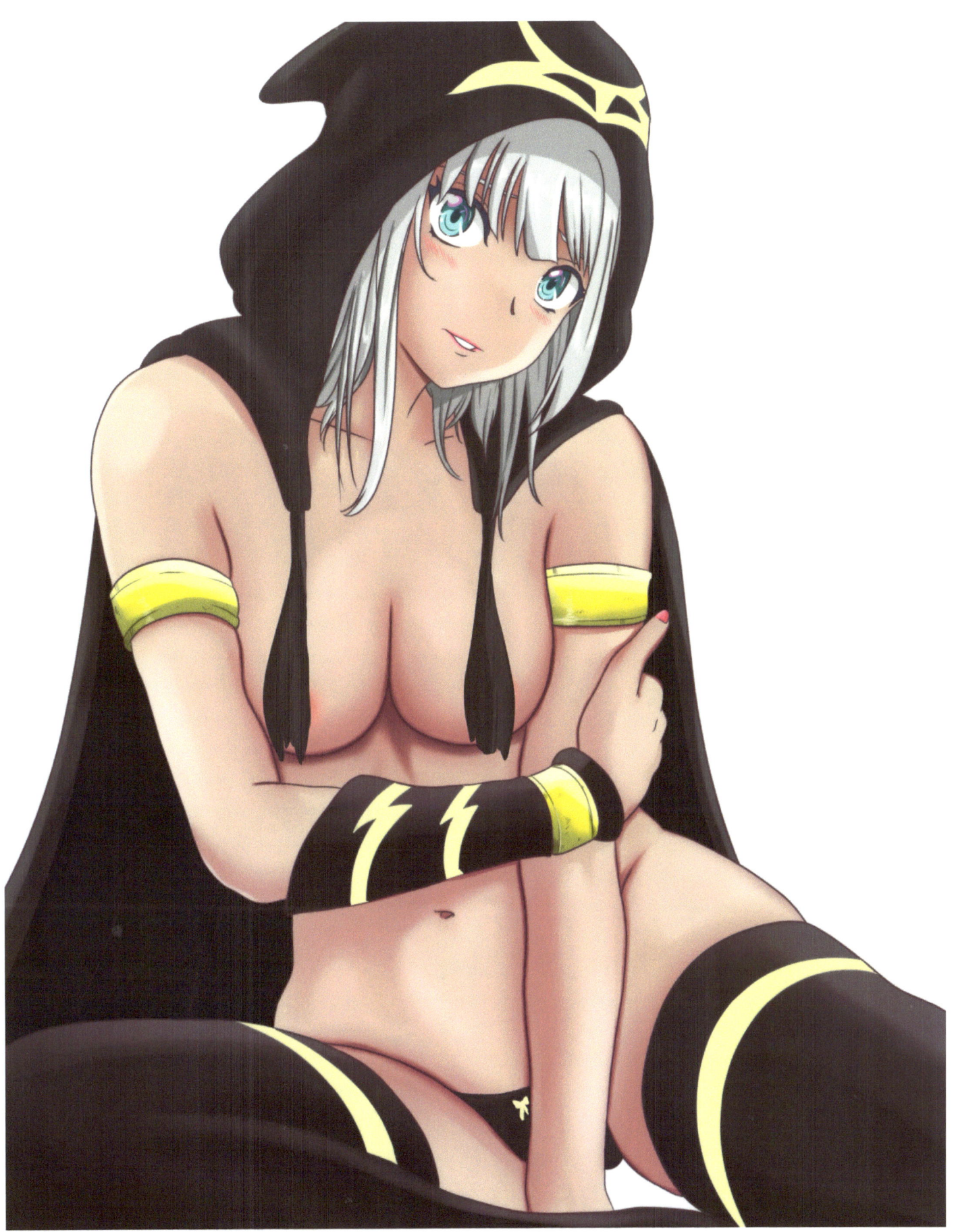

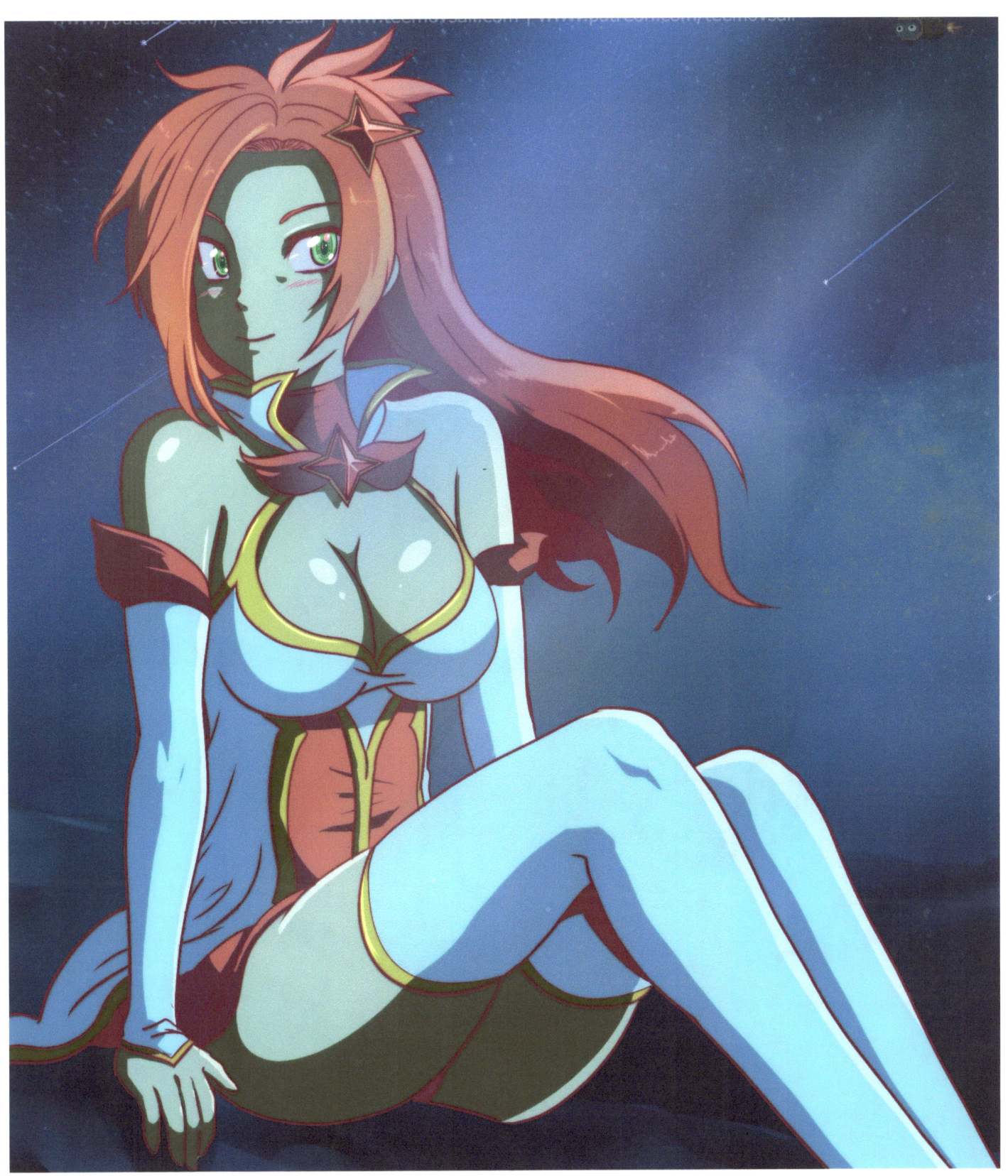

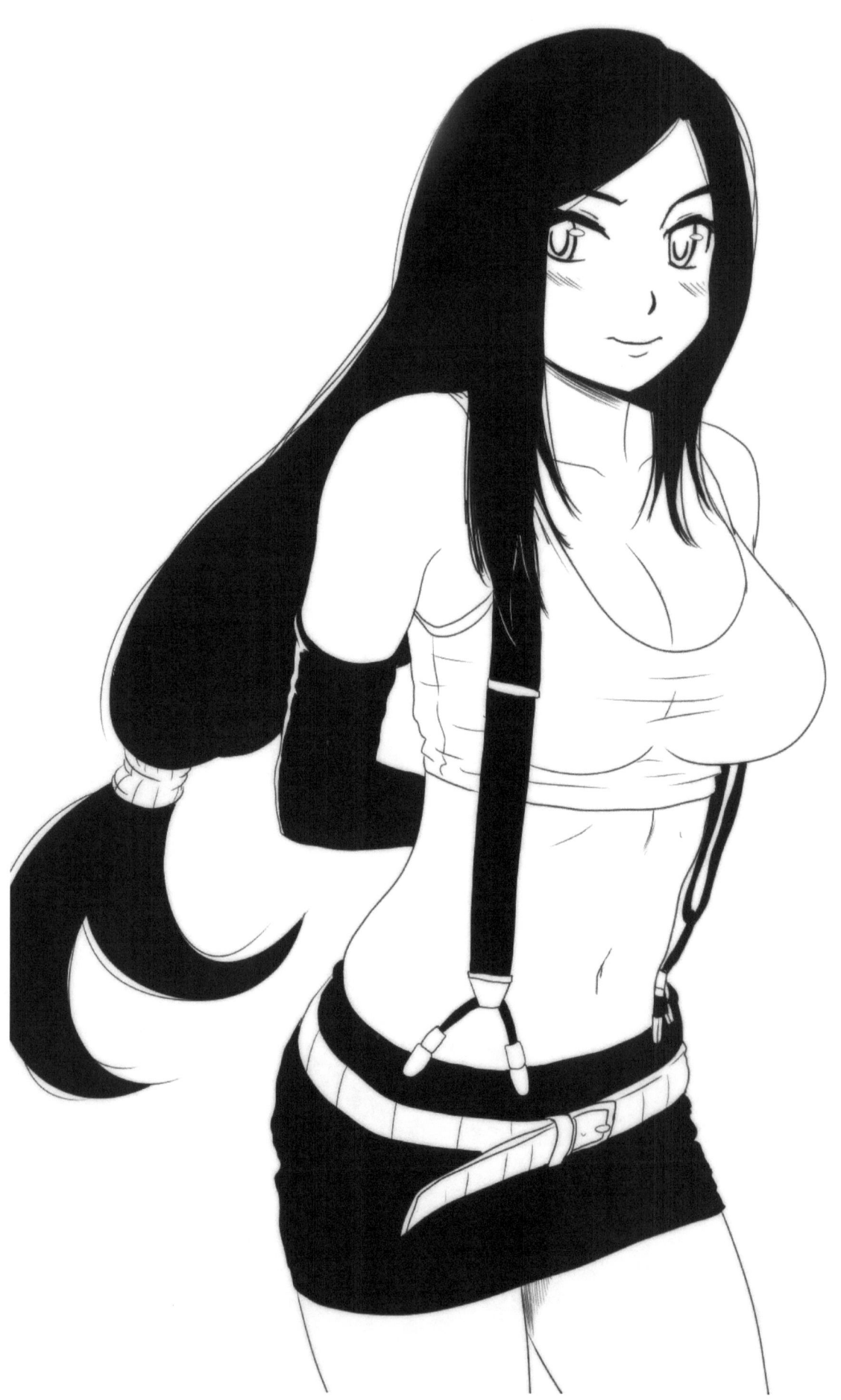

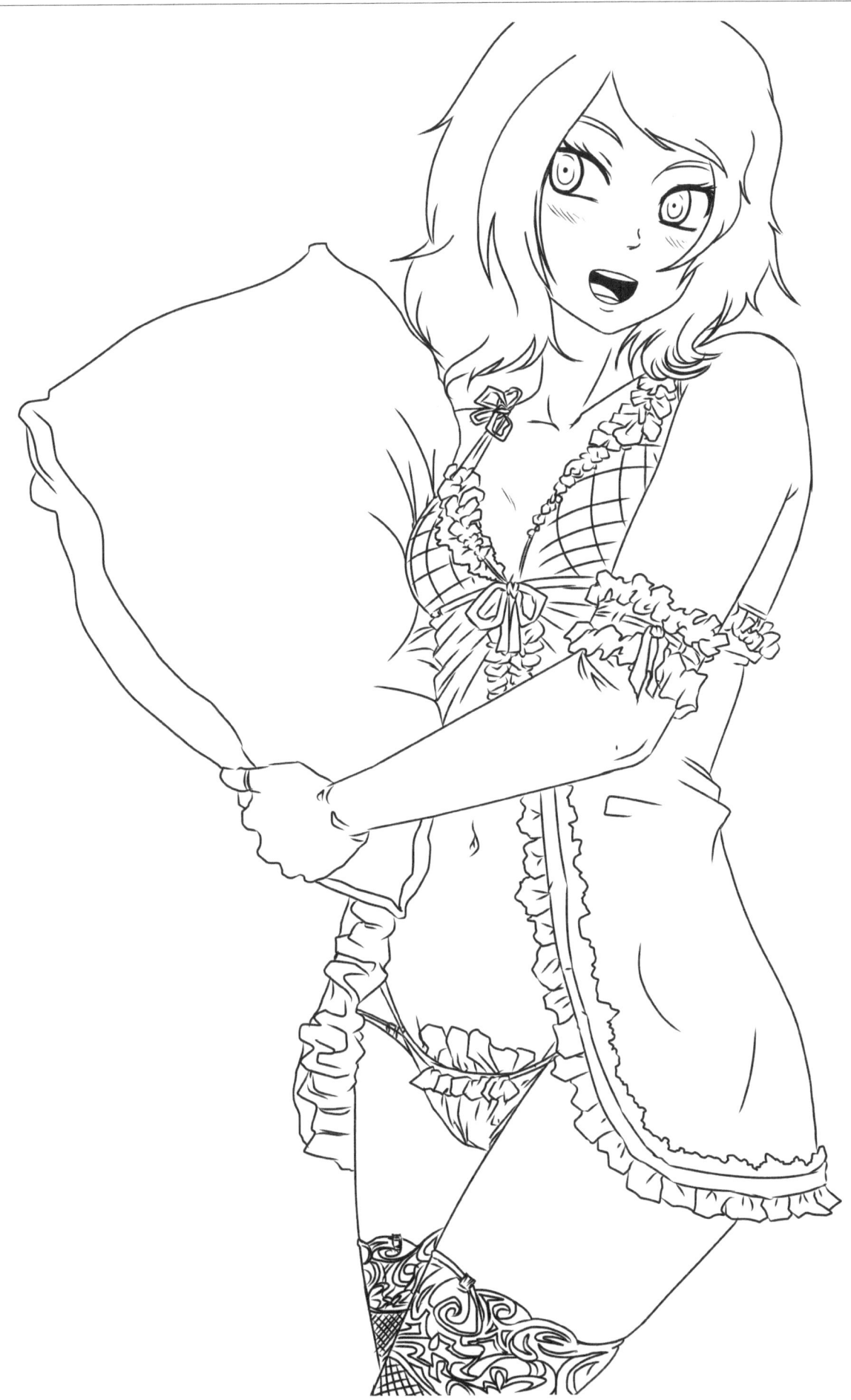

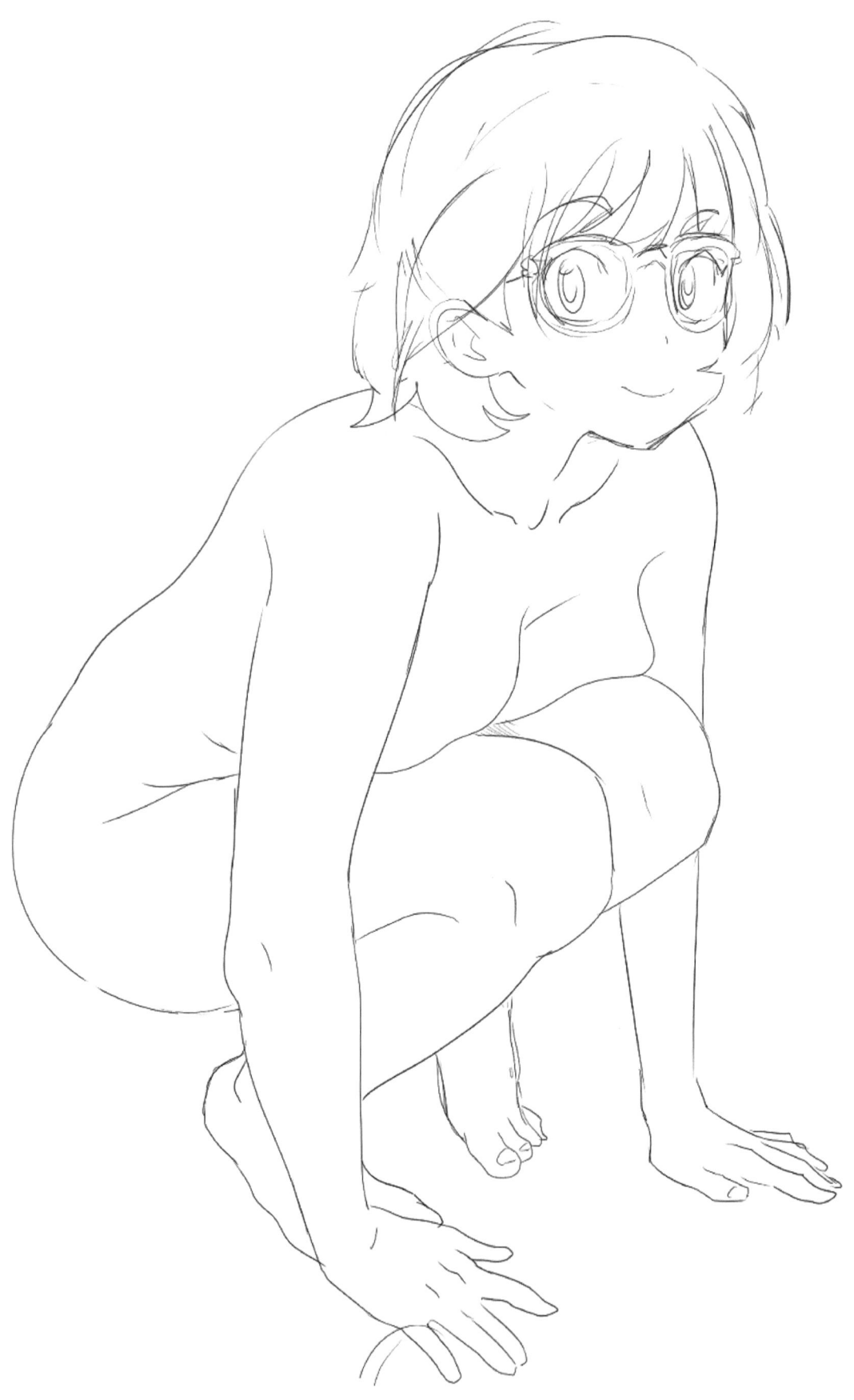

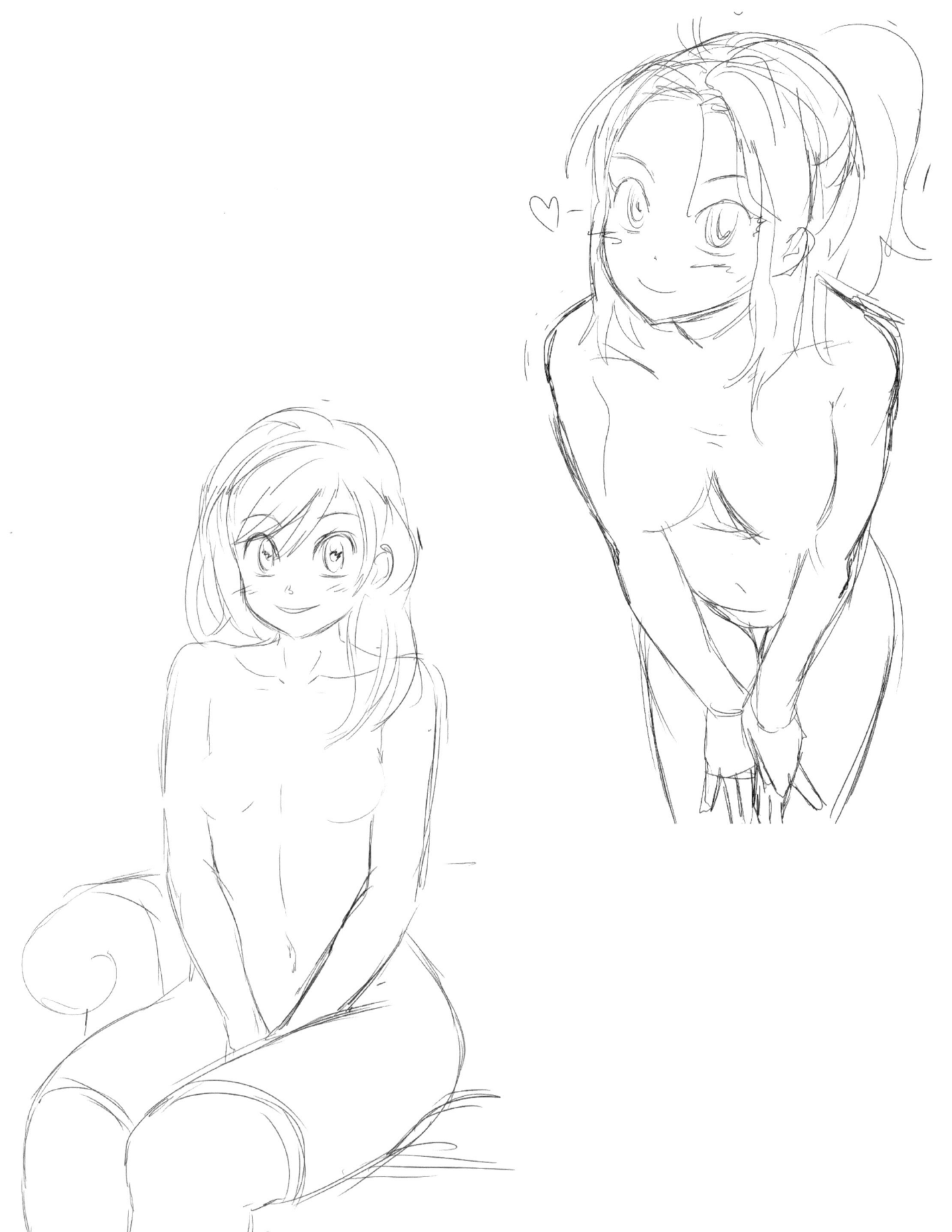

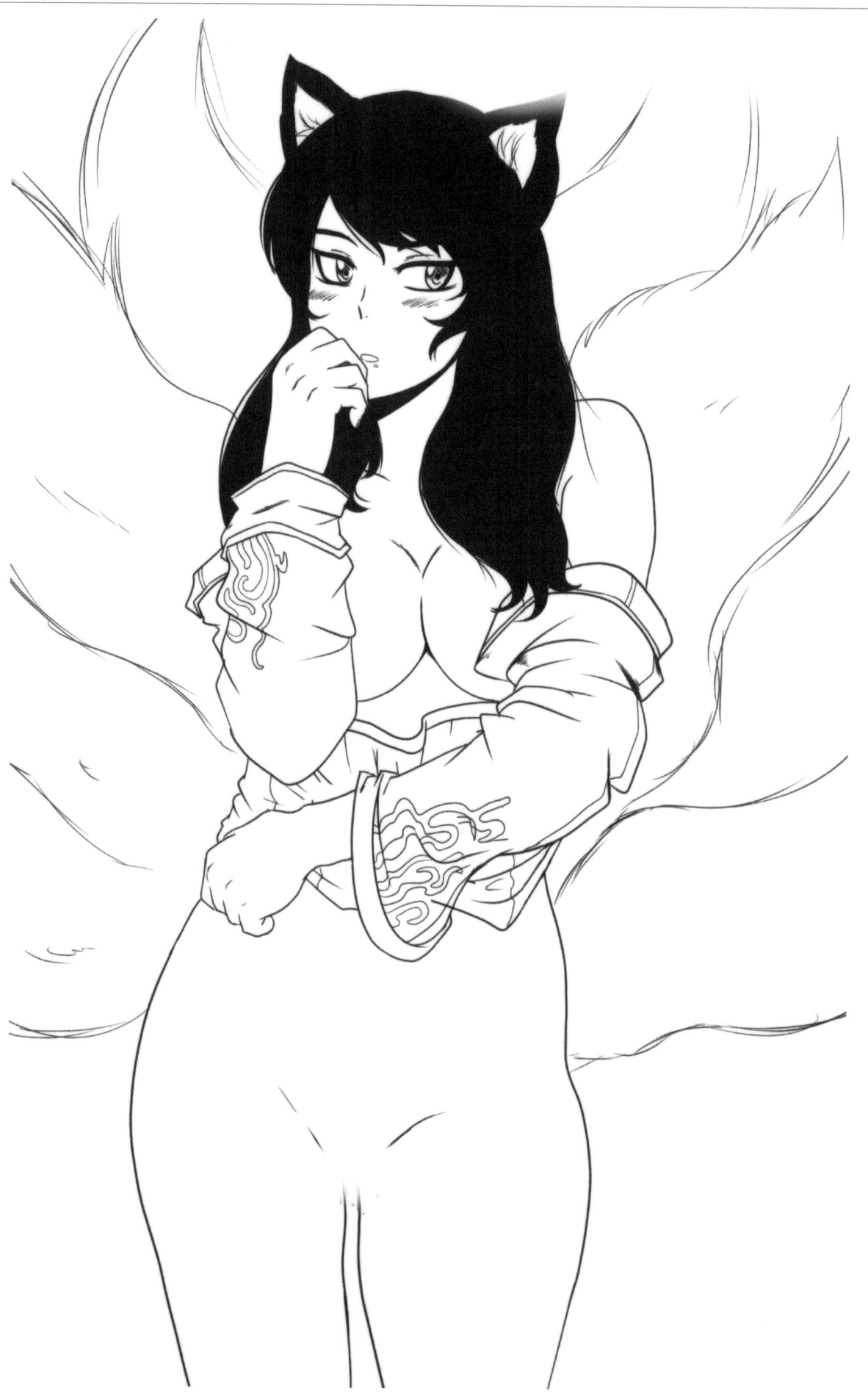

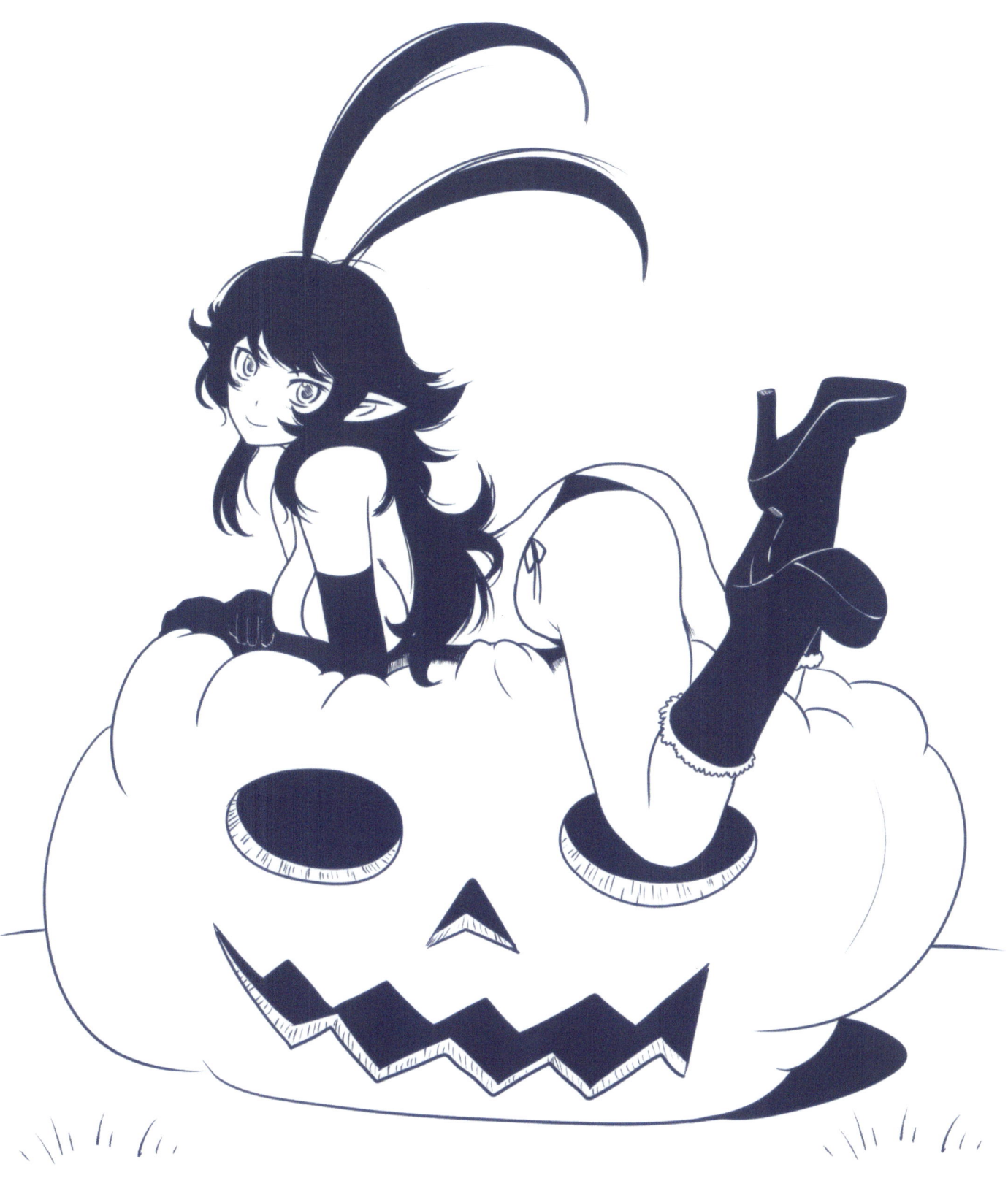

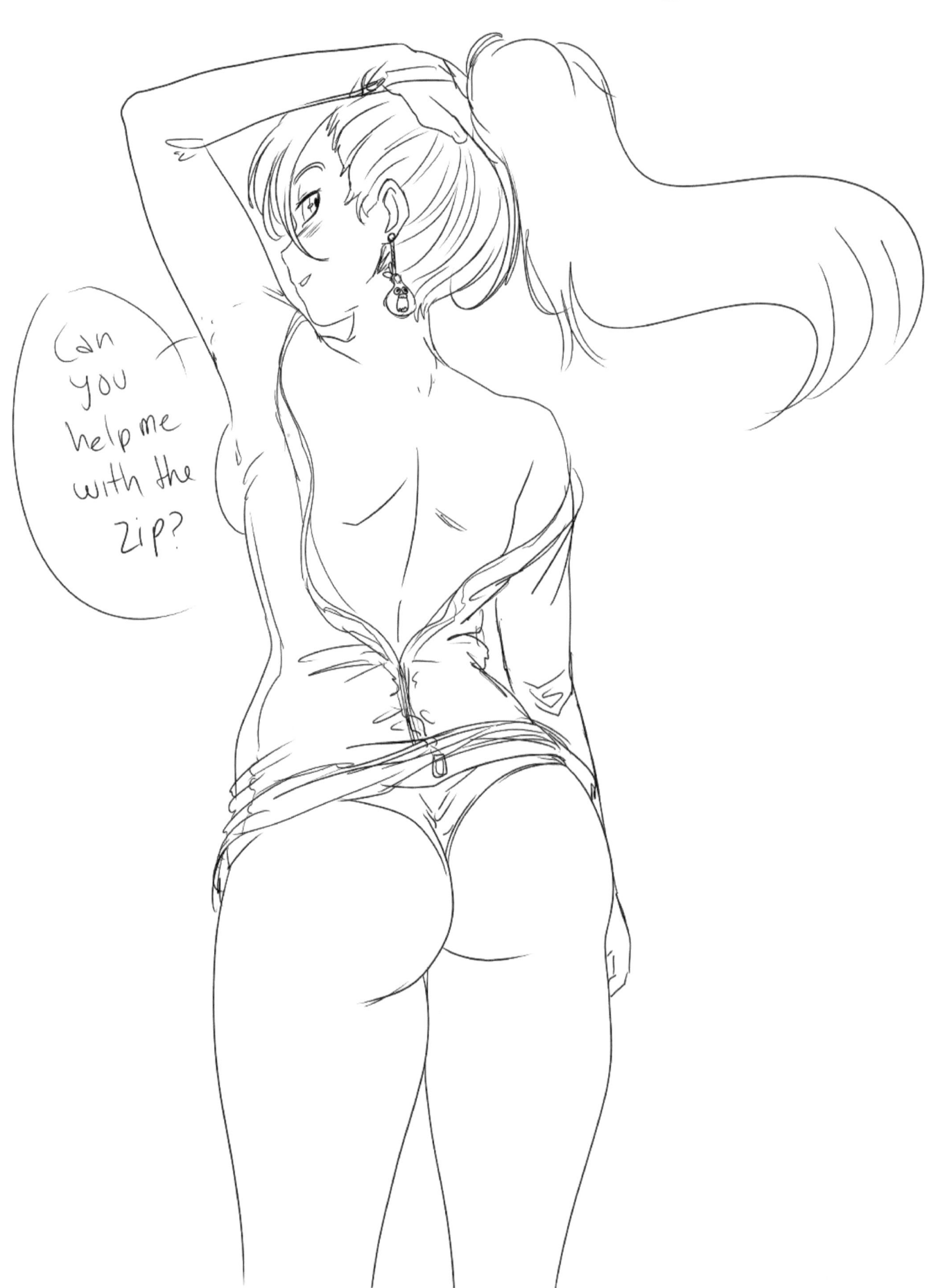

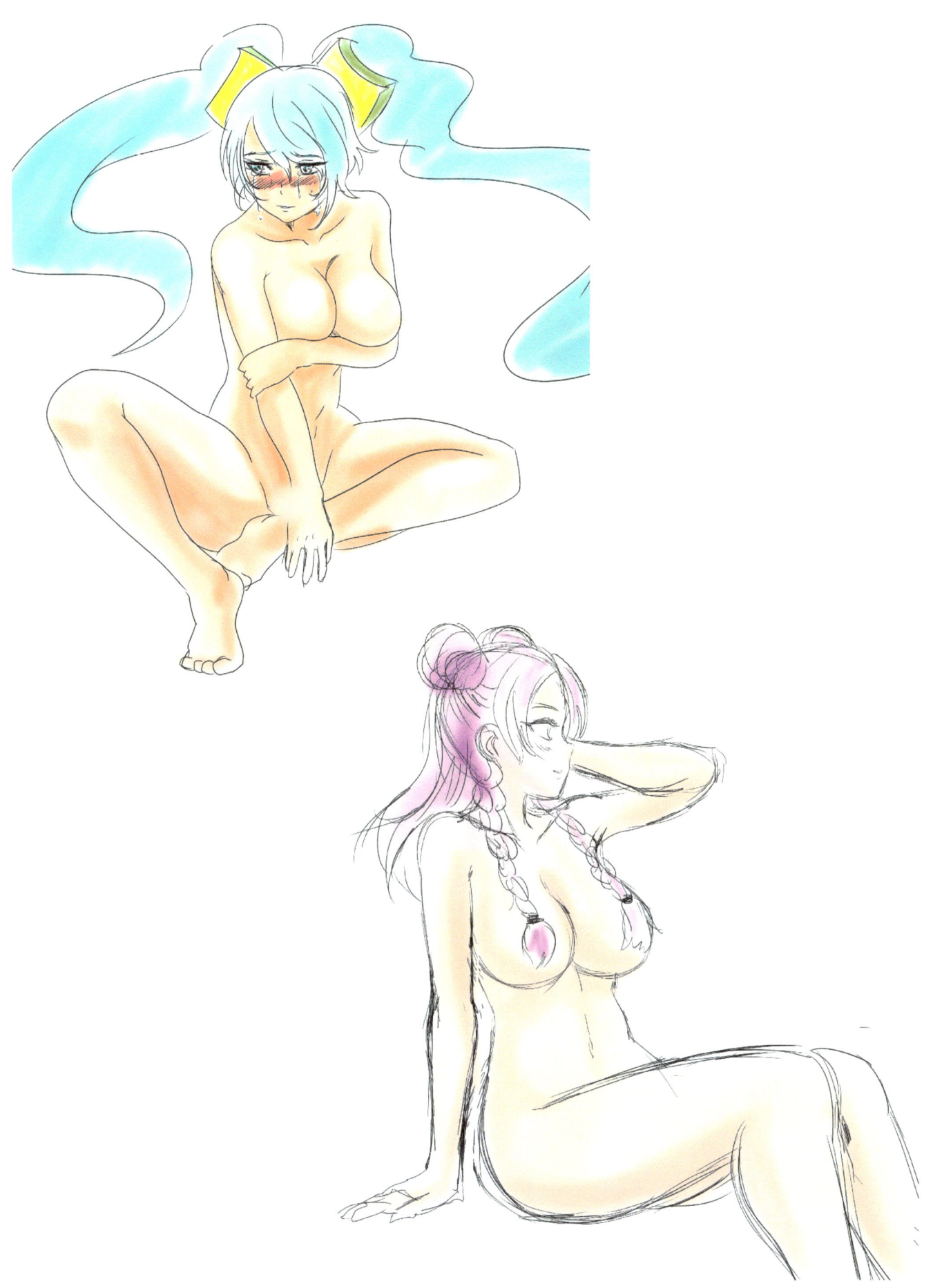

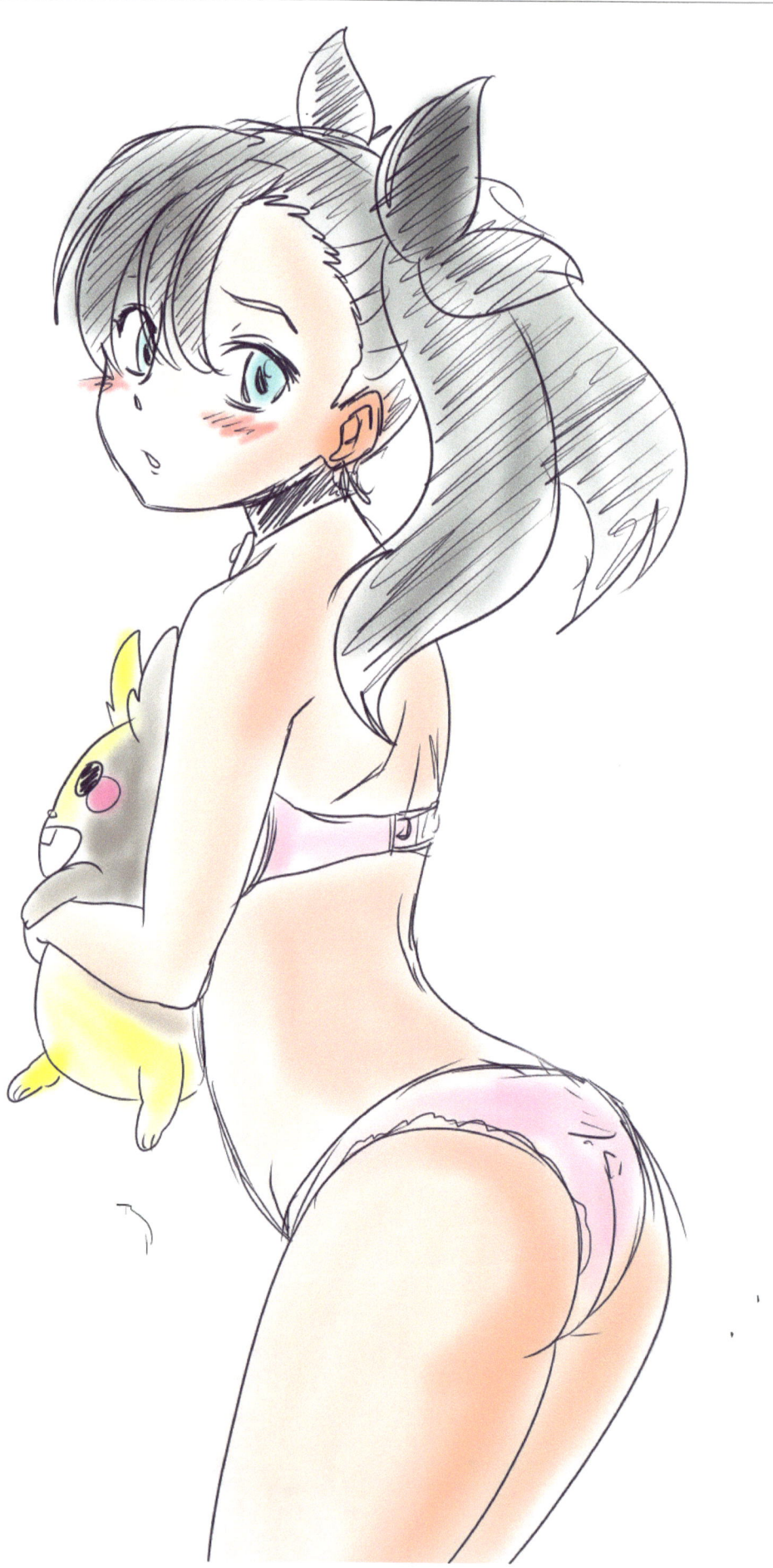

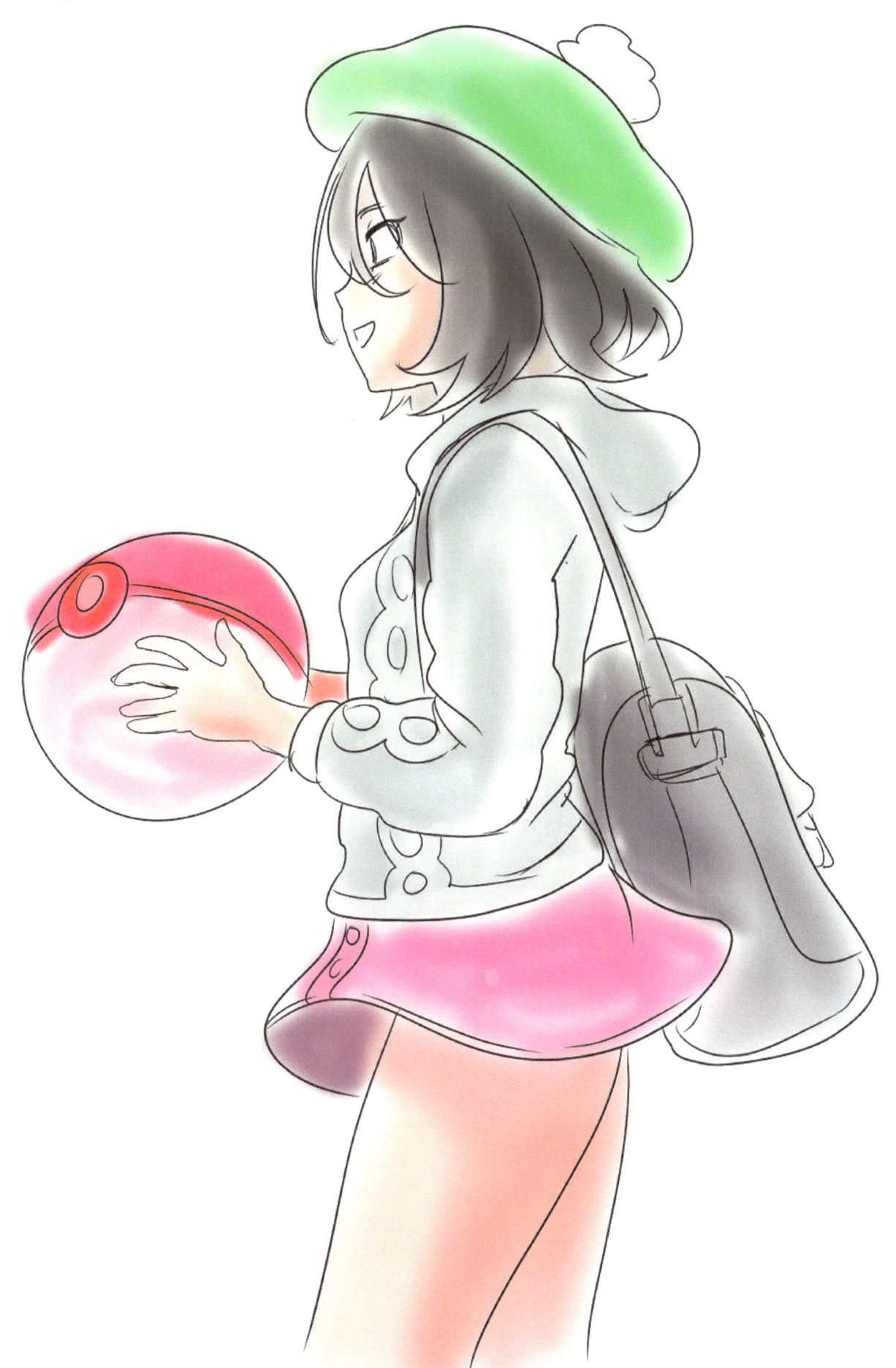

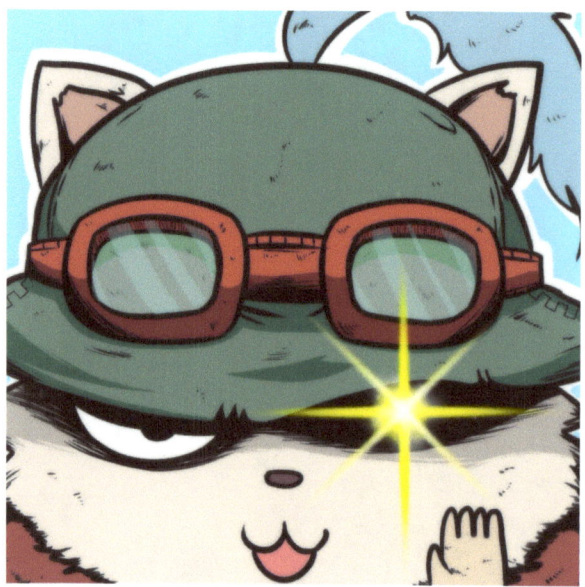

Agradecimientos a:

Todos los Patreon que me apoyan y a todos los seguidores de Youtube que sin ellos, hoy no tendría este artbook.

Y gracias a ti por comprar este artbook!

Teemovsall

Sincere thanks to:

All the Patreon that support me and all the Youtube fans that without them, today I would not have this artbook.

And thank you to buy this artbook!

Teemovsall

www.ingramcontent.com/pod-product-compliance
Lightning Source LLC
Chambersburg PA
CBHW050942200526
45172CB00020B/531